FRA ANGELICO

FRA ANGELICO
Christopher Lloyd
with notes by David White

Phaidon Press Limited
Regent's Wharf, All Saints Street, London N1 9PA

Phaidon Press Inc.
180 Varick Street, New York, NY 10014

www.phaidon.com

First published 1979
Second edition, revised and enlarged, published 1992
Reprinted 1993, 1994, 1998, 2001
© 1979, 1992 Phaidon Press Limited

ISBN 0 7148 2785 1

A CIP catalogue record of this book is available from the
British Library.

Printed in Singapore

Cover illustrations:
(front) *The Annunciation*, c.1432-3 (Plate 7)
(back) *The Entombment*, c.1440 (Plate 25)

Fra Angelico

Fra Angelico is one of those unfortunate artists who have become prisoners of their own reputation. Beginning with Giorgio Vasari, and extending right up to the present day, there has been a tendency to exaggerate his links with the monastic world. Thus Vasari, in his *Lives of the Most Eminent Painters, Sculptors, and Architects*, after a careful account of Fra Angelico's works, concludes his biography of the artist with an analysis of his character:

> Fra Giovanni was a man of the utmost simplicity of intention, and was most holy in every act of his life. ...He laboured continually at his paintings [and] used frequently to say, that he who practised the art of painting had need of quiet, and should live without cares or anxious thoughts. ...It was the custom of Fra Giovanni to abstain from retouching or improving any painting once finished. He altered nothing, but left all as it was done the first time, believing, as he said, that such was the will of God. It is also affirmed that he would never take the pencil in hand until he had first offered a prayer. He is said never to have painted a Crucifix without tears streaming from his eyes, and in the countenance and attitudes of his figures it is easy to perceive proof of his sincerity, his goodness, and the depth of his devotion to the religion of Christ.

Vasari here directly equates the strength of Fra Angelico's religious conviction with his ability as a painter, implying that in some indefinable way the quality of his paintings was related to his mode of living.

In the nineteenth century, with the revival of interest in early Italian painting, Vasari's characterization of Fra Angelico assumed almost gigantic proportions. Writers such as Lord Lindsay in *Sketches of the History of Christian Art* (1847) and Alexis-François Rio in *De l'Art Chrétien* (1861) adopted a quasi-mystical approach to Italian primitive painting in general and to Fra Angelico in particular. This approach reaches a climax in a book entitled *Art Studies* (1861) written by the American collector James Jackson Jarves, who declared that 'Fra Angelico is the St. John of art.' This adulation was not just a literary indulgence; it had a practical outlet as well during the nineteenth century. When the German Nazarene painters – those intrepid precursors of the Pre-Raphaelites – settled in Rome in 1810, they were known as the Brotherhood of St Luke and took up residence in the monastery of Sant'Isodoro, thereby emulating Fra Angelico, in whose paintings they saw a perfect fusion of the Ideal with Nature. On a more urbane level, but equally revealing, is an anecdote recorded in the *Journals* (1895) of Lady Eastlake, the wife of Sir Charles Eastlake, the first Director of the National Gallery in London. When, in August 1858, the Eastlakes took a painting ascribed to Fra Angelico to be examined in Milan by the famous restorer and Keeper of the Brera Gallery,

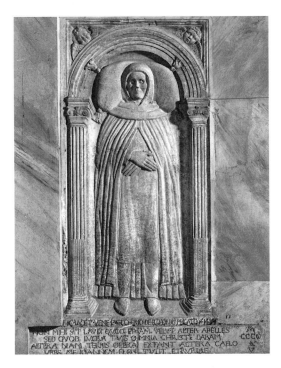

Fig. 1
Tomb-slab of
Fra Angelico
Santa Maria sopra
Minerva, Rome

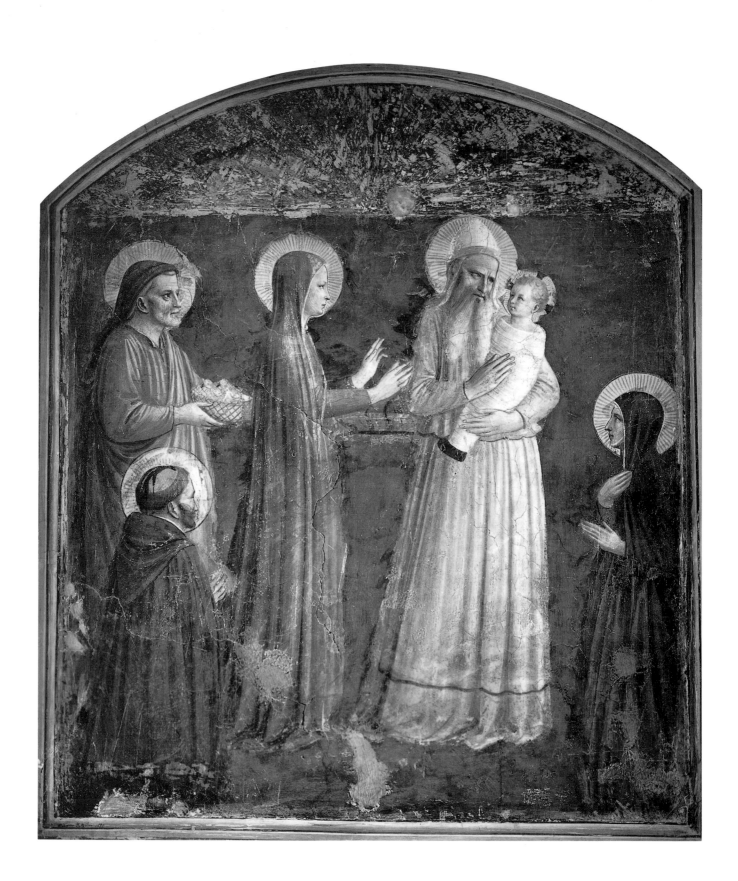

Giuseppe Molteni, they were told: 'Fra Angelico was an angel, I am but a man.'

It is true to say that anyone today who looks at Fra Angelico's paintings does so as heir to this purely emotional response. Yet it needs to be emphasized that Fra Angelico's supreme qualities as a painter stem more from his mastery of style than from the sanctity of the subject-matter. With this in mind it is necessary first to summarize the main events of his life before examining the works of art themselves.

The artist's real name was Guido di Piero di Gino, although after his religious profession he was called simply Fra Giovanni da Fiesole. He was born in the Mugello, an area to the north-east of Florence near Vicchio. The exact date of birth is not known, but Vasari mistakenly asserted that Fra Angelico was 68 when he died in Rome in 1455, thus implying a birth date of 1387. While the date and place of death are indeed correct, the age at which the painter is supposed to have died is erroneous. The vital error was compounded by another of more recent origin, namely that Fra Angelico took the habit in 1407. It has now been shown that he was still a layman in 1417, and not until 1423 is he referred to as a friar. Fra Angelico therefore seems to have joined the Dominican Community at Fiesole sometime between 1417 and 1421, allowing two years for his profession. Interestingly, the document of 1417 already refers to him as a painter and concerns the advancement of his name by the miniaturist Battista di Biagio Sanguigni for membership of the Compagnia di San Niccolò in the church of Santa Maria del Carmine in Florence. All this indicates that Fra Angelico was probably born around 1400, and the revision of this essential date means that he belonged to the same generation as Masaccio, as opposed to that of Masolino. This, as will be seen, is of some significance when considering Fra Angelico's role in the evolution of Florentine painting.

The other documents in which Fra Angelico is mentioned provide information about two spheres of his life. Firstly, they refer to his career within the Dominican Order. The Order was at this time expanding in Tuscany as a result of a reform movement initiated at the end of the fourteenth century and known as the Dominican Observance. The teaching of the Dominican Observants by such distinguished minds as those of Giovanni Dominici and Antonino Pierozzi, later Archbishop of Florence, was to exercise a powerful influence over Fra Angelico's paintings. Indeed, a late painting of *Christ on the Cross with the Virgin and St John the Evangelist adored by a Dominican Cardinal* (Plate 48) evokes a meditative calm that can be readily compared with the writings of Giovanni Dominici, Antonino Pierozzi, and the Spanish Cardinal Juan de Torquemada, who has been identified as the cardinal depicted on this panel kneeling at the foot of the cross.

Fra Angelico is first recorded as a friar in 1423 in the convent of San Domenico at Fiesole. Here he held office as Vicario, remaining in Fiesole after 1435 when a number of monks had moved into the city of Florence, eventually to establish themselves in the convent of San Marco. The painter himself did not move to San Marco, the place so widely associated with his name, until after a lapse of a few years; he is, in fact, first recorded there in 1441. Again, in the larger convent of San Marco, he held office, this time as *sindicho*, which appears to have been a post with some financial responsibilities. The architect of the new buildings at San Marco was Michelozzo, one of the finest and most modish exponents of Brunelleschi's architectural principles. Fra Angelico's work in the convent included the painting of the high altarpiece in the church (Plate 24) and the decoration of the cells, cloisters and corridors (Plates 28-31). These works, especially the frescoes in the cells, cloisters and corridors (Fig. 2), served a particular purpose within

Fig. 2
The Presentation in
the Temple
c.1441-3. Fresco,
151 x 131 cm.
San Marco (Cell 10),
Florence

the monastic community, and they were painted in an advanced style that exploited both the requirements of the monks and the most recent developments in Florentine art. In 1450 Fra Angelico was appointed Prior of San Domenico at Fiesole, where he succeeded his own brother Fra Benedetto. No doubt it was a combination of his position within the Order and his reputation as a painter that led to the choice of the main Dominican church in Rome, Santa Maria sopra Minerva, for his burial-place.

The second sphere of Fra Angelico's life illuminated by the documents is his reputation as an artist. He was much in demand even beyond the monastic communities of San Domenico at Fiesole and San Marco in Florence, and we know of commissions and negotiations dating from various decades of his life: in Brescia (1432), Cortona (1438), Orvieto (1447), Prato (1452), and Rome (c. 1445-9 and c. 1453-5). Apart from the works carried out in these places, Fra Angelico is twice recorded acting as an assessor in the valuation of works of art executed by contemporaries. The first occasion was in 1434, together with Rossello di Jacopo Franchi, for an altarpiece painted largely by Bicci di Lorenzo in the church of San Niccolò oltr'Arno. The second occasion was considerably later, in 1454, when it was deemed that frescoes painted in the Palazzo dei Priori in Perugia should be assessed either by Filippo Lippi, Domenico Veneziano, or Fra Angelico. The nomination of such illustrious alternatives indicates the standing that Fra Angelico had in Florentine art.

Of all the opportunities presented to Fra Angelico for working outside Florence, the most prestigious was undoubtedly the invitation to travel to Rome, initially at the behest of Pope Eugenius IV and then of Pope Nicholas V. The papacy was at this time still consolidating its position in Rome and throughout Italy after the Schism. This policy took many forms, but outwardly its most impressive manifestation came in the revival of the arts, exemplified by the restoration of the main churches and the development of the city as a modern urban complex, including the establishment of the Vatican as a permanent papal palace. The policy reached a climax in the Jubilee celebrations of 1450 and found a more permanent expression in the gradual rebuilding of St Peter's and of the Vatican. Each of the Popes concerned (Martin V, Eugenius IV and Nicholas V) attracted a host of artistic talent to Rome, but none more successfully than Pope Nicholas V, who was a considerable scholar in his own right and who was, for example, prepared to pay his translators of classical texts virtually double what he paid Fra Angelico. As at San Marco, so in Rome Fra Angelico was engaged in decorating newly constructed or adapted buildings, and what impresses us today is the speed and efficiency with which he completed these different tasks. Between 1446 and 1449 Fra Angelico painted no fewer than four different fresco cycles in various chapels in the Vatican, only one of which has survived intact (in the Chapel of Pope Nicholas V, otherwise referred to as the Chapel of St Lawrence and St Stephen, Plates 33-37), while one of the others (in the Chapel of the Sacrament) was described by Vasari before its destruction for rebuilding. Fra Angelico's facility is rare even for an age that nurtured such expeditious fresco painters as Benozzo Gozzoli and Domenico Ghirlandaio. In carrying out such an ambitious programme of work, Fra Angelico undoubtedly benefited from an almost faultless technique, but he also had recourse to a number of studio assistants. Of these, Gozzoli was the most distinguished, though in both Rome and Orvieto Fra Angelico used a whole team of helpers. Yet the role of these assistants while they remained in Fra Angelico's workshop was a subordinate one, usually limited to mundane executant duties; the design and

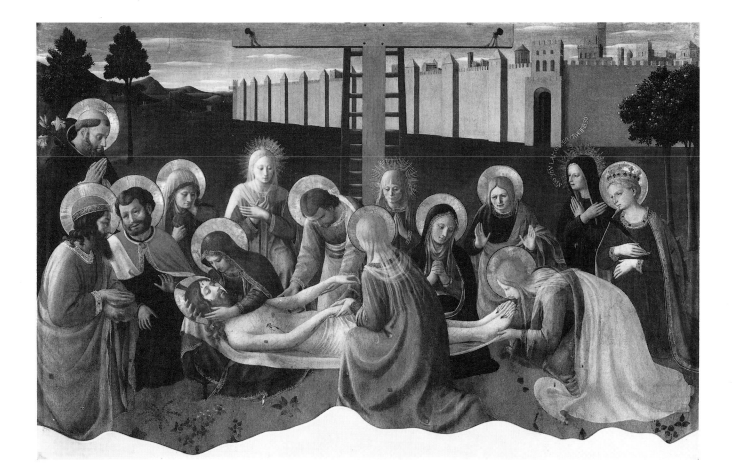

Fig. 3
The Lamentation
over the Dead Christ
1436. Panel, 105 x 164 cm.
San Marco, Florence

the finish remained the master's. The fact that Fra Angelico used assistants, therefore, in no way detracts from his achievements in Rome, and his work there, carried out mainly for Pope Nicholas V, is amongst the earliest of those extensive papal commissions that gradually resulted in the supremacy of the Eternal City over Florence as an artistic centre.

The documents, however, are far less informative about specific paintings. The dates of the fresco cycles are established, principally by detailed records of payments, but only five of the altarpieces can be precisely dated: that for San Pietro Martire in Florence (now in the Museo di San Marco) in 1429; the triptych for the Arte dei Linaiuoli (now in the Museo di San Marco, Plates 10 and 11) in 1433; *The Lamentation over the Dead Christ* (Fig. 3) for the Confraternità di Santa Maria della Croce al Tempio in Florence (now in the Museo di San Marco) in 1436; the polyptych for San Domenico in Perugia (now in the Galleria Nazionale dell'Umbria, Perugia, Plates 20, 22 and 23) in 1437; and the polyptych for San Domenico, Cortona (now in the Museo Diocesano, Cortona; Plate 21) in 1438. Other works, both in fresco and on panel, have been assigned various dates on the basis of style, but this has led to certain difficulties over the chronology of the painter's oeuvre, which is still not a settled matter.

The most important formative influences on Fra Angelico are only referred to indirectly in the documents. Considering his connections with the miniaturist Battista di Biagio Sanguigni, it is hardly surprising that he also painted miniatures at the outset of his career. Many of these, after his profession, were presumably for San Domenico at Fiesole (Plates 2 and 3), and several drawings attributable to him (Plate 1) appear to have been executed on spare pieces of vellum. A document of 1418 refers to a lost altarpiece painted by Fra Angelico for the

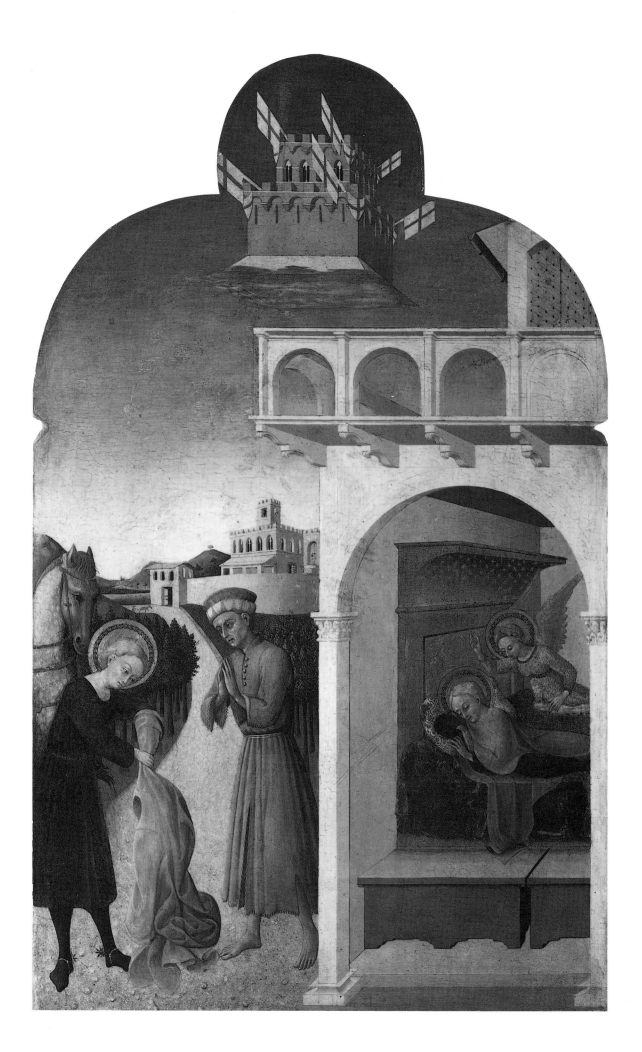

church of Santo Stefano al Ponte in Florence, where Ambrogio di Baldese, a follower of Orcagna, was employed in decorating the walls of the chapel and had indeed originally been commissioned to paint the altarpiece as well. The juxtaposition of the frescoes by Ambrogio di Baldese with an altarpiece painted by Fra Angelico is not without some significance, since the central panel of Fra Angelico's early altarpiece for San Domenico at Fiesole (Plate 4) bears a striking resemblance, both stylistically and in the facial type of the Virgin, to those few panels now ascribed to Ambrogio di Baldese.

The affiliation of the Compagnia di San Niccolò to the church of Santa Maria des Carmine in Florence is also significant. Certain of Fra Angelico's early works display a knowledge of Masaccio in the solidity of the human frame and in the chiaroscural system of modelling. At first, Fra Angelico reduces the stylistic features derived from Masaccio to a smaller scale, but in his altarpieces one can observe a gradual progression that reveals an increasing confidence in the treatment of spatial intervals. Like his important predecessor Gentile da Fabriano, whose work in Florence and Rome the master must have studied, Fra Angelico's principal achievement was to develop a feeling for the monumental without sacrificing the lyricism inherent in his style. Thus there is a wide range in his oeuvre, extending from small, minutely painted, almost bejewelled panels such as *The Last Judgement* (Plate 6) to massive altarpieces like the Linaiuoli triptych, which, with its marble frame and folding wooden shutters designed by Lorenzo Ghiberti, is the largest such altarpiece executed during the fifteenth century and is in many ways directly comparable with sculptural projects (Plates 10 and 11). There is a similar range in Fra Angelico's treatment of narrative. In his predella panels, which, as regards scale and facture, are similar to his manuscript illuminations, one is always struck by the heightened sense of drama contained within a small space. The aged Elisabeth surmounting the steep hill from which one can view the full panoply of the southern Tuscan landscape in *The Visitation* (Plate 8), a predella panel from *The Annunciation* at Cortona (Plate 7), is an unforgettable image, especially if one has oneself climbed the hill to Cortona, a town which Henry James described as being 'nearer to the sky than to the railway station', in order to see the altarpiece. Similarly, the scenes from the predellas of the Linaiuoli triptych, the Perugia polyptych, or the altarpiece for San Marco (Plates 25-27), abound with vividly depicted passages of narrative painting. This supreme ability, which Fra Angelico shared with his contemporaries Sassetta (Fig. 4), Filippo Lippi and Pesellino, was also transferred on to a monumental scale in his frescoes, notably in those in the Chapel of Pope Nicholas V (Plates 33-37). In this combination of the monumental with the lyrical, Fra Angelico epitomizes the achievement of the Early Renaissance. What concerned artists of the first half of the fifteenth century was to depict the world around them with the greatest possible degree of verisimilitude. This concern was not limited to the depiction of the human form, but included the space within which that form moved, so that the setting, as well as the figures, had to be seen to comply with natural laws. Certain theoreticians of the fifteenth century, both mathematicians and painters, believed that a mathematically based system of perspective was the correct way to render the world surrounding them with the greatest possible fidelity to nature. Yet, while this did undoubtedly assist painters, there were other technical devices that could aid them. Fra Angelico himself, for instance, combined in his compositions a system of one-point perspective, usually applied empirically, with his ready skills in the drawing and modelling of the human figure (Fig. 5).

Fig. 4
Sassetta:
The Wish of the Young St Francis to become a Soldier
1437-44. Panel,
87 x 52.4 cm.
National Gallery, London

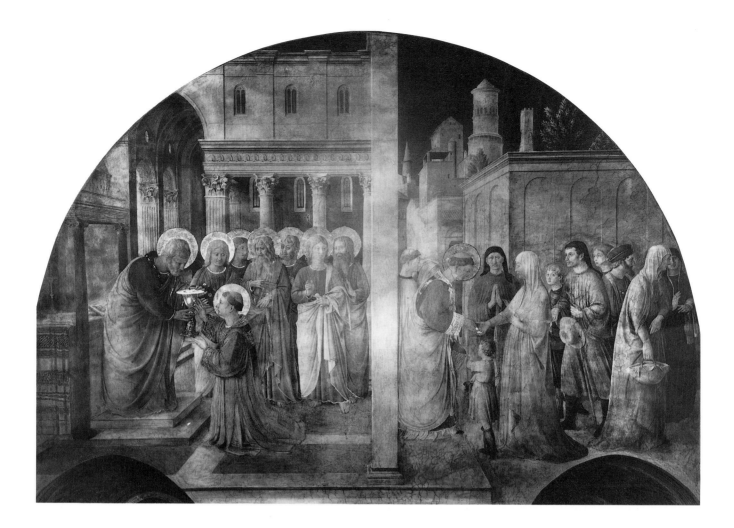

Fig. 5
The Ordination of
St Stephen and
St Stephen
distributing Alms
c.1447-8. Fresco. Chapel
of Pope Nicholas V,
Vatican

Fra Angelico's treatment of space is best demonstrated by an examination of the centre panels of three of his principal altarpieces. On the altarpiece for San Domenico at Fiesole, the main panel of which was originally tripartite, the Virgin and Child sit on a tall throne placed upon a marble base with a curved front jutting out towards the spectator (Plate 4). The Virgin seems to sit on the edge of the throne, whilst the *baldacchino* itself is encircled by angels. Before the throne on the patterned floor kneel two more angels seen in three-quarters profile. In the two later altarpieces, executed for the churches of San Domenico in Perugia (1437) and Cortona (1438), these two angels have been replaced by vases of flowers (Plates 20 and 21), which, though inanimate, are no less effective in defining the sense of distance between the seated Virgin and the spectator. The base of the throne in the Perugian altarpiece (Plate 20) is square, and the angels are more carefully distributed around the Virgin than in the altarpiece at Fiesole (Plate 4). The two angels behind pop their heads round the back of the throne in an almost playful way, while the pair at the front carry baskets of roses. The angel in front on the right confronts the spectator with a direct stare, which reinforces the direction of the Child's gaze. In the altarpieces in Perugia and Cortona the Virgin is more firmly placed on the throne than in the Fiesole altarpiece, but, even when due allowance is made for the damaged state of the Perugian altarpiece, that in Cortona is perhaps the more successful of the two (Plate 21). In this the composition is slightly more orthodox in that the angels are positioned behind the arms of the throne, but the spatial progression from the vases on the floor in the immediate foreground to the back of the altarpiece is more carefully measured. The throne is made

of marble. It is square at the top. There are two heads painted in monochrome placed in tondi in the spandrels, and spiral columns with corinthian capitals decorate the sides. The back of the throne is shaped in the form of a curved niche, topped by a round-headed arch with filigree work. The Virgin sits on a piece of patterned drapery that echoes the decoration around the back of the niche. The figure of the Virgin with the Child standing on her left knee is imposing, the shape of the body being suggested by the folds of the drapery and the puckering of the cloth. There is no ambiguity in the poses of the angels. They are intent upon the task of adoring the Virgin and Child, and, in so doing, set an example to the spectator.

In addition to these three altarpieces, which are strictly traditional in format, there are those in which Fra Angelico has unified the main visual content of the altarpiece on a single panel. These form an impressive series, extending from *The Annunciation* at Cortona (Plate 7), through *The Deposition from the Cross* (Plate 12) and the San Marco altarpiece (Plate 24) to *The Coronation of the Virgin* in the Louvre (Plate 39). The first of these works makes telling use of a simple device for the convincing depiction of space, namely the interlocking of the figures within an architectural setting. The loggia in which the Annunciation takes place is positioned slightly obliquely to the picture plane, so that one side of it is seen receding into the distance towards the back of the picture. This row of arches carries a cornice that leads the eye to the incident in the upper left corner of the altarpiece, which is directly related to the momentous event taking place in the cloistered privacy of the foreground. In the upper left corner Fra Angelico has shown the Angel with the flaming sword expelling Adam and Eve from the Garden of Paradise, an event that is balanced theologically by the Annunciation itself, whereby man is granted the possibility of eventual redemption. God the Father is located in a tondo immediately above the column that separates the Archangel Gabriel from the Virgin. The gaze of God the Father is directed downwards, towards the Virgin. The whole scene is illuminated by light entering the picture apparently from the right. The main incident is bathed in the full glare of this light, which strikes the arches extending backwards in the picture with a similar force. Yet the Expulsion of Adam and Eve is shown with a supernatural light shining from the Garden of Paradise, 'fierce as a comet', in Milton's phrase. It is as though the Angel had suddenly opened a door, thereby emitting bright rays into the surrounding darkness. If, therefore, it is the architectural elements that visually link the subsidiary scene to the Annunciation, it is the two principal figures who reinforce the horizontal axis of the composition as a whole. The Virgin is seated near the right edge, She is seen in three-quarters profile, her arms crossed in a gesture of humility. The book she has been reading rests precariously on her right knee and may slip to the ground at any moment. The Archangel Gabriel stalks into the loggia, the tip of his wings extending as far as the left edge of the panel. The picture space is divided vertically into three parts by the two columns in the foreground. The figures are placed beneath two arches, but neither is completely contained by its respective arch, so that we receive an impression of dramatic movement from left to right. Although *The Annunciation* portrays a private moment, which the spectator is privileged to witness, we are kept at a distance and not admitted to the loggia, being separated from it both physically and psychologically by the columns.

The Deposition from the Cross (Plates 12-17) is in an elaborate frame, the pinnacles of which were painted by Lorenzo Monaco. It is presumed that the altarpiece was begun by Lorenzo Monaco and left

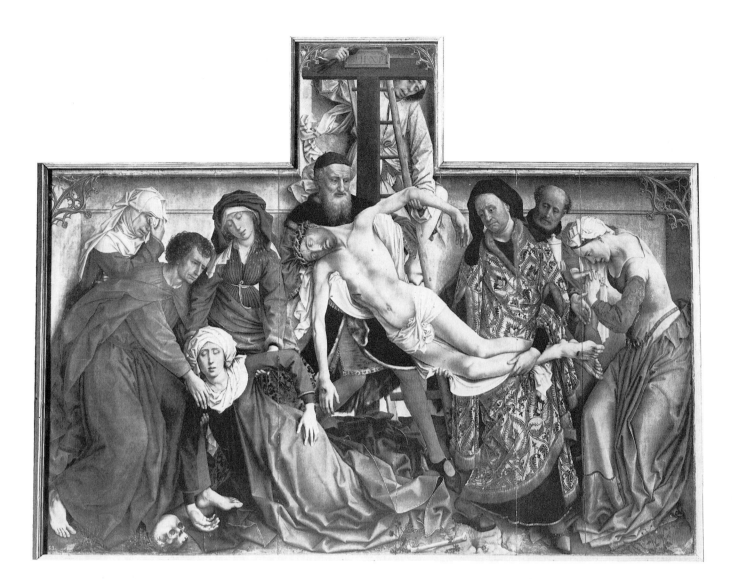

Fig. 6
Rogier van der
Weyden:
The Deposition from
the Cross
Before 1443. Panel,
220 x 262 cm.
Prado, Madrid

unfinished at his death in 1424, the main panel then being undertaken by Fra Angelico. The altarpiece was set up in the sacristy of the church of Santa Trinita in Florence, which was patronized by the Strozzi family, and may have been painted sometime during the 1430s, presumably before 1434 when the Strozzi family were banished from Florence. It is not known how much freedom Fra Angelico was given in determining the subject-matter and format of the altarpiece, but at all events the composition is particularly daring for a work dating from the first half of the fifteenth century. Indeed, it is not dissimilar from Rogier van der Weyden's *Deposition* (Fig. 6), now in Madrid, the composition of which could have been known to Fra Angelico through an engraving. The Florentine altarpiece has a pronounced vertical axis in the centre, marked by the cross, the ladders, and the figures lowering the dead body of Christ. This central part of the altarpiece is related to the side fields geometrically by a triangle. The left side of the triangle extends down the trunk of Christ's body to the kneeling figure of Mary Magdalen, who is seen in profile kissing the feet of Christ. The right side of the triangle is indicated by Christ's left arm, which joins the young St John to the kneeling figure in the foreground seen in three-quarters profile, now identified as a member of the Strozzi family, Beato Alessio degli Strozzi. The pose, gesture, and secular status of this figure imply that he acts as an intermediary on behalf of the spectator. Ranged on either side of the cross, and presided over by hovering angels, are the mourning female figures on the left and the attendant

male figures, possibly including Nicodemus and Joseph of Arimathaea, on the right. The range of characterization in the portrayal of these individuals, reacting in their different ways to the horror of Christ's death, is remarkably vivid, and the effect is enhanced by the sharp light entering the picture from the left. Behind these groups of figures are memorable passages of landscape painting. Beyond the male figures is a view of the undulating Tuscan countryside dotted with outlying habitations and trees, or, as John Ruskin wrote of Tuscany in a letter of 1845, 'one vista of vine and blue Apennine, convents and cypresses'. Beyond the female figures is a city representing Jerusalem with the Temple of Solomon rising above all the other buildings. The gateways and the wall, with its series of watch-towers protecting the areas of cultivated land just beyond the perimeter of the city, are exquisitely rendered with the precision of a miniaturist, and sharply defined by the interaction of light and shadow. These two sections of the painting are so well executed, in fact, that they remind one of the shallow relief found on the bronze panels of Ghiberti's Gates of Paradise for the Baptistery in Florence (Fig. 7).

Perhaps the most influential of the altarpieces painted by Fra Angelico is that, now rather damaged, executed about 1440 for the church of the convent of San Marco in Florence (Plates 24-27). The composition has a high viewing-point, so that the spectator looks down on the elegant carpet that leads up to the steps of the throne. On this carpet are positioned two pivotal figures: St Cosmas to the left and St Damian to the right. The former implores us in a somewhat theatrical way, with a pathetic gesture and a plaintive expression, to look towards the Virgin, whilst the latter, with his back to the spectator, underlines the invitation, since it seems as though he is a member of the congregation of the main body of the church. These two figures are connected with the Virgin and Child by a simple piece of geometry, in that they form a triangle with them, just as the attendant saints and angels stretched out on either side of the Virgin and Child form the sides of another, larger triangle. The system of perspective also helps to stabilize the composition. The orthogonals on the oriental carpet all lead towards the Virgin and Child, and the distribution of the figures around them creates a feeling of a *sacra conversazione* which the spectator is witnessing – an impression that is reinforced by the looped curtains at the sides, drawn back as though especially for us to see this *tableau vivant*. The high viewing-point means that the figures do not overcrowd the panel as in *The Coronation of the Virgin* (Plate 39), and it is important to realize how Fra Angelico has united the upper and lower halves of the composition. There is in the centre a strong vertical axis. The Virgin sits on a tall marble throne with a rounded arch and fluted pilasters topped by corinthian capitals and supporting a wide cornice with an entablature. It is a throne very much in the idiom of Brunelleschi, but its real importance for this composition is that it projects almost to the upper edge of the panel. Similarly, the Virgin's head is above the level of the heads of all the other figures. The altarpiece is also divided horizontally into three sections by the carpet below, the backcloth in the middle in front of which the saints stand, and the landscape background above with its rows of cypress and orange trees. The floral swags at the top echo those decorating the cornice of the throne and their curvature recalls that of the looped curtains which reach down to the backcloth, so that the eye, should it follow these lines of suggested pattern, prescribes the outer limits of the upper half of the altarpiece. There is also another geometrical relationship operating on the surface of the panel. The kneeling saints form diagonals that extend into the four corners of the altarpiece and at the

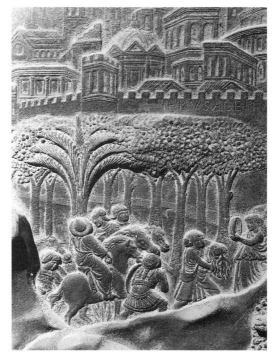

Fig. 7
Lorenzo Ghiberti:
Detail from 'David returning to Jerusalem with the Head of Goliath'
Bronze panel.
Second door of the Baptistery, Florence

same time pass through the figure of the Virgin, thereby drawing attention to the Christ Child. This type of *sacra conversazione* – which Fra Angelico used in two other compositions, though with less dramatic impact (Plates 32 and 38) – was of immense importance for the development of Renaissance painting during the second half of the fifteenth century.

The last of these altarpieces with a unified composition is the large-scale *Coronation of the Virgin* (Plates 39-41), which has been variously dated in the 1430s or as late as about 1450, and was originally painted for the church of the convent of San Domenico in Fiesole. This altarpiece shows how skilfully Fra Angelico could manipulate a vast chorus of figures, for the coronation takes place amid a throng of people. The throne is of large dimensions. It is canopied, decorated by spiral columns on either side with corinthian capitals, and lined with patterned drapery and comfortable cushions. The figures virtually amount to a full cast of Fra Angelico's characters: angels neatly dressed, intent upon their duties or else concentrating upon playing their musical instruments with puffed-out cheeks and deft fingers, and awe-inspired saints, armed with their respective attributes. Those seen in the foreground, kneeling on the patterned floor, are swathed in drapery. In some cases, particularly that of St Agnes on the right holding the lamb, the drapery falls in elegant tubular folds to the ground, whereas the cope of St Nicholas of Bari, seen just to the left of centre in the foreground, is taut, as though pulled together too forcibly at the front. It is a highly worked cope with scenes from Christ's Passion in the embroidered panels at the back, and blends in well with the crowns, diadems and jewels worn by the other saints.

In designing this *Coronation of the Virgin* Fra Angelico set himself a difficult problem in relating the patterned floor to the steep flight of marbled steps. He overcame this, however, by using a single, extremely high vanishing-point for the whole altarpiece, which serves to focus our attention on the coronation at the top (Fig. 8). Furthermore, he reinforces this with other indications, such as the jar held in Mary Magdalen's left hand. This jar forms the centre of a circle on the perimeter of which, near the upper edge, are the Virgin and Christ. The circle echoes a larger one comprising the figures positioned around the throne, the centre of which falls in the middle of the flight of steps. Writers have all too easily found fault with Fra Angelico's design of this altarpiece, but the overall impact is, in fact, extremely dramatic. The void left in the centre of the panel, for instance, is not only supremely evocative, but is also compositionally of the greatest possible significance. It is the void around which all the figures gyrate, but at the same time it is the area through which the vertical axis passes, so that the eye has no difficulty in ascending the steep flight of steps until it reaches the focal point of the altarpiece. This vertical line is punctuated only by the jar held by Mary Magdalen and by the quill which the saint on her left is holding. Both these figures are positioned immediately below the Virgin and Christ, and again this vertical emphasis helps to weld together the upper and lower halves of the panel. Such a moment of quietude as this void represents amidst the resplendent throng reveals Fra Angelico at the height of his powers, and the altarpiece cannot justifiably be described as 'one of the few works in which Fra Angelico was thrown off his stride by strenuous efforts to keep up with the innovations visible around him'. Comparison with the earlier and much smaller panel of the *Virgin and Child Enthroned with Twelve Angels* (Plate 5) shows that the painter was already aware of the dramatic potentialities of this kind of circular composition set within a panel of vertical format. Here, though, in *The*

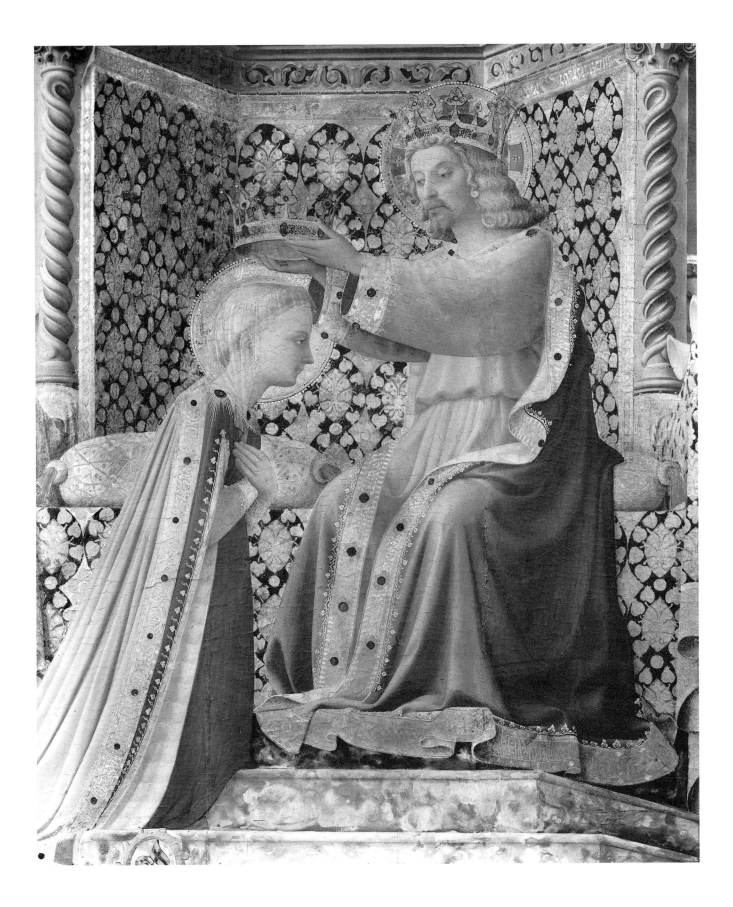

Coronation of the Virgin (Plate 39), as in *The Deposition* (Plate 12), Fra Angelico can be seen controlling a host of figures within a closely defined architectural setting. It is an extension of *The Annunciation* at Cortona (Plate 7), and in designing the composition Fra Angelico creates a degree of flexibility that is also found in the altarpiece painted for the church of the convent of San Marco (Plate 24).

Fra Angelico's compositional powers included his rendering of narrative. In the predellas to his altarpieces, perhaps as a result of his training as a miniaturist, he succeeds in relating an incident vividly, usually with a minimum of figures. For instance, the predella to the San Marco altarpiece, illustrating scenes from the lives of St Cosmas and St Damian, emphasizes the important role accorded these titular saints in the main part of the altarpiece. Two of these scenes (*The Decapitation of St Cosmas and St Damian* and *The Dream of the Deacon Justinian*), the first located in a landscape and the second in an interior, serve to show how compactly the painter treated his narrative subjects. In the former (Plate 26) the two saints with their three brothers are being put to death in front of a neat row of slender cypress trees just outside a city wall. The figures are roughly disposed on a diagonal leading from the lower left corner of the panel to the upper right corner, a line of vision that extends from the act of brutality in the foreground to the stillness of the hillside in the background. There is a telling contrast between the tense body of the kneeling saint about to be beheaded and the lithe body of the executioner, seen from the back, raising his two-handed sword as he strides forward to administer the final blow. Similarly, there is a dramatic contrast between the floral carpet and the decapitated bodies, and also in a more general sense, between the beauty of the setting beneath 'a vault of deepest sapphire' and the horror of the act. Indeed, the rhythm of the executioner's deadly stroke is echoed by the curve of the road bending round at the foot of the row of hills. *The Dream of the Deacon Justinian* (Plate 27) also achieves dramatic results by the simplest means. There is a crispness in the handling of paint and in the treatment of light that bespeaks some knowledge of contemporary Netherlandish painting, notably in the depiction of the window on the left and the view into the passage through the doorway on the right. The scene depicts a posthumous miracle performed by St Cosmas and St Damian, who during the course of the fifteenth century became the patron saints of the Medici and were assigned medical attributes. In this panel the saints are shown replacing the cancerous leg of the Deacon Justinian with a good leg removed from an Ethiopian man recently deceased, thereby anticipating modern surgical practice. The Deacon lies peacefully asleep while the saints, one on either side of the bed, perform the transplant operation with a sense of urgency and a degree of concentration demanded by the occasion. Fra Angelico has here taken great care with the still-life objects. There is the stool on the left, which is seen half in shadow and half in light; the Deacon's shoes, which he has left tidily by the bed; and the bed clothes, as well as the accoutrements of nocturnal rest, either suspended from the bed-head, or balanced precariously on top of it. The scene has a slightly theatrical air. The two saints have clearly entered through the door on the right, which has been left open for a sudden departure. The bed is raised upon a dais. The curtains that the Deacon would no doubt have pulled around him before going to sleep are looped over the rail and catch the glimmering light of the approaching dawn. The images in these two predella panels belonging to the San Marco altarpiece are direct and simple. They are painted with a factual precision but are raised to a higher, almost poetic level by the painter's fertile imagination and powers of observation.

The reformer of the Dominican Order and later its Vicar-General, Giovanni Dominici (1357-1419), exhorted painters to return to the traditional values of spirituality and to adopt a clear, economic style devoid of unnecessary emotion and religious anachronisms. The most admirable demonstration of these criteria is provided by the series of frescoes executed by Fra Angelico, with his workshop assistants, on the upper floor of the convent of San Marco (Plates 28-31). These frescoes were painted in the corridors of the convent and the individual cells of the monks. They were intended to assist the monastic community in fulfilling their religious vows. Interestingly, John Ruskin referred to these particular frescoes as 'visions' when he saw them in 1845. Beginning with *The Annunciation* (Plate 28) at the top of the staircase, the frescoes relate the course of Christ's life from his Birth to his Passion, but only one scene, the *Sermon on the Mount*, illustrates the Ministry. Some of the cells are decorated solely with a fresco of Christ on the Cross, either with or without the ancillary figures. The images are memorable because of their touching simplicity. Both the settings and the figures are restrained by a degree of objectivity which suggests that Christ's life is here being described, or merely recorded, rather than enacted. The painter appears to have deliberately limited the number of figures in the frescoes, and the settings are uncomplicated. Elsewhere in the convent, painted at about the same time, are representations of Dominican saints intended to remind the monks of their allegiance to the Order, the most memorable being *St Peter Martyr enjoining Silence*. These frescoes in San Marco include some of the best-known images in Fra Angelico's oeuvre, and indeed the unemotional depiction of these scriptural events induces in the beholder a feeling of meditative calm and of spiritual confidence (see Plate 30). Few renderings of the Transfiguration are as challenging and as totally convincing as that painted in Cell No. 6 at San Marco (Plate 31).

There is a similar potency about the equally famous series of panels that once decorated the doors of the silver chest in the church of the Santissima Annunziata in Florence (Plates 42-45 and Fig. 9). These were begun by Fra Angelico about 1451, probably at the behest of Piero de' Medici, but not completed until after the artist's death, in part by Alesso Baldovinetti. The panels depict scenes from the life of Christ, but there are some extra scenes such as *Pentecost, The Coronation of the Virgin*, and *The Last Judgement*. Two other scenes are included for theological purposes: *The Vision of Ezekiel* at the beginning and the *Lex Amoris* at the end. *The Vision of Ezekiel* (Plate 42) is a composition in the form of a wheel. Ezekial is shown in the lower left corner at the moment of his vision. He is balanced on the right by Gregory the Great, who wrote a commentary on the relevant biblical passage. Around the hub of the wheel are eight standing figures of the Evangelists and the writers of the canonical epistles, and next to the rim are twelve seated figures of prophets. The image is really a scriptural disquisition in the medieval manner and the literary connotations in this first panel of the series are echoed in the inscriptions placed along the upper and lower edges of each of the other panels, which amount to quotations of parallel texts from the Old and New Testaments. Regardless of their learned allusions, these panels from the silver chest are among Fra Angelico's best-loved compositions (Plate 45).

Fra Angelico's finest work, however, is the series of frescoes in a small chapel in the Vatican (Plates 33-37). The Chapel of Pope Nicholas V is approached through the Stanza della Segnatura and the Stanza d'Eliodoro painted by Raphael when he was at the height of his powers. Entering the Chapel after witnessing the intellectual prowess

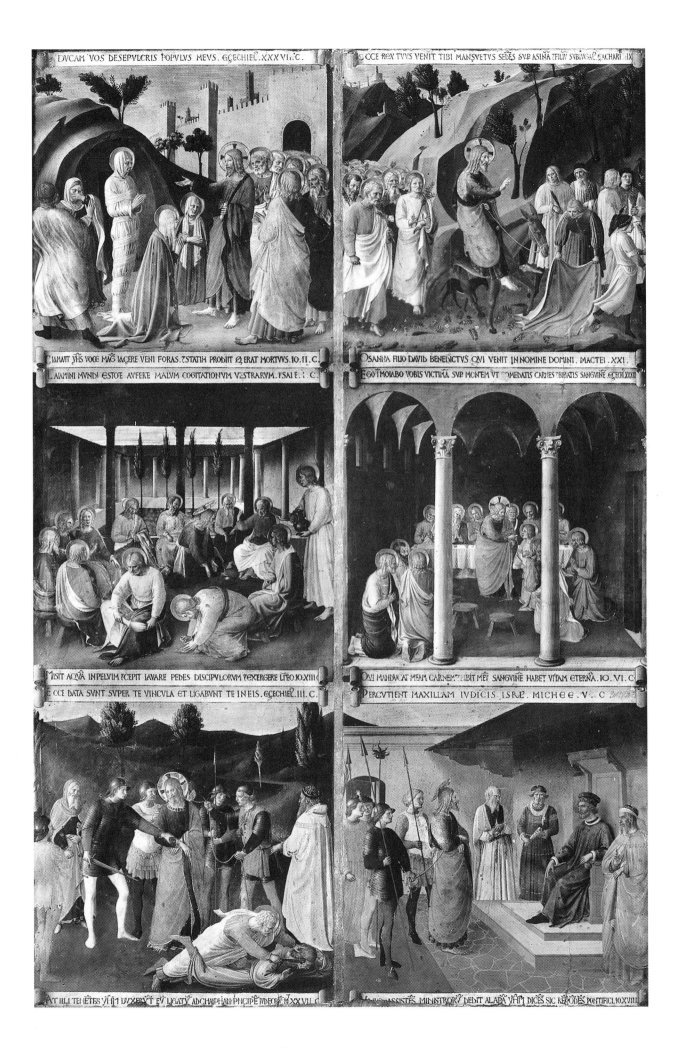

of Raphael is like plunging into a pool of clear water. The Chapel is rectangular and of small dimensions, with a high ceiling. The narrative frescoes are painted on three sides of the room and comprise three lunettes illustrating six scenes from the Life of St Stephen, with five scenes from the Life of St Lawrence below on the main parts of the walls. Flanking the frescoes on the lateral walls and extending into the vault are eight full-length figures of the Doctors of the Church standing under elaborate canopies. In the four fields of the ribbed vault are the Evangelists. There can be little doubt as to why Fra Angelico was asked to paint scenes from the lives of the Deacons Stephen and Lawrence, for these are the Church's two protomartyrs, whose activities and martyrdoms served to emphasize the primacy of Rome. It is not surprising to discover that the features of Pope St Sixtus II in the frescoes of *The Ordination of St Lawrence* (Plate 37) and *St Lawrence receiving the Treasures of the Church* (Plate 34) are those of Pope Nicholas V himself.

In its judicious selection of Fra Angelico as its official painter, the papacy was richly rewarded. It is here in Rome that one sees the master's compositional powers at their most developed. The narrative is concisely expressed and the chosen scenes from the lives of the two deacons are made, as far as was feasible, to balance one another. The frescoes represent an advance in Fra Angelico's narrative powers in that the scenes are more densely populated than was usual in his earlier compositions. They also have far richer architectural settings, or, in one isolated instance (*The Expulsion and Stoning of St Stephen*), the landscape is treated on a panoramic scale and is less self-contained than was customary (Plate 36). Where the frescoes are paired, the architectural elements help to unify the compositions. The architecture is thus not used merely as a background, but is given a positive role in the interpretation of the scenes. The only pairing in which this system is not successfully applied is that of *St Lawrence receiving the Treasures of the Church and St Lawrence distributing Alms* (Plate 34 and Fig. 10).

It is possible that Fra Angelico's more persistent use of architecture in these frescoes is related to his freshly awakened interest in building, which resulted from what he saw being constructed in Rome whilst he was working in the Vatican. The frescoes of *St Lawrence distributing Alms* and *The Ordination of St Lawrence* (Plate 37) do certainly reflect contemporary architectural designs, and the background of the latter was probably inspired by the erection of the tribune in Old St Peter's, which was then being discussed with Leon Battista Alberti and was shortly to be begun after a design by Bernardo Rossellino, though it was never finished.

The influence of Fra Angelico's frescoes in the Vatican on his successors who worked there has never been sufficiently stressed and there are, it seems, points of contact between the Chapel of Pope Nicholas V and the frescoes by Raphael in the Stanza della Segnatura (Fig. 11). The substitution of the features of Pope Nicholas V for those of Pope St Sixtus II in *The Ordination of St Lawrence* (Plate 37), and elements of the composition itself, are also found in Raphael's fresco of *Pope Gregory IX approving the Decretals of the Church*, where Pope Gregory IX is accorded the features of Pope Julius II. Similarly, it is surely not too fanciful to find in Fra Angelico's masterly treatment of the recession of the columns in the background of *St Lawrence distributing Alms* (Plate 34) the germ of an idea that resulted in the background of the more spacious hall in which Raphael set his fresco of *The School of Athens*. If these visual connections are valid, then they may be taken as a supreme compliment to Fra Angelico by his illustrious successor in the Vatican.

Fig. 9
Six Scenes from the Life of Christ
c.1451. Panel, each 39 x 39 cm.
San Marco, Florence

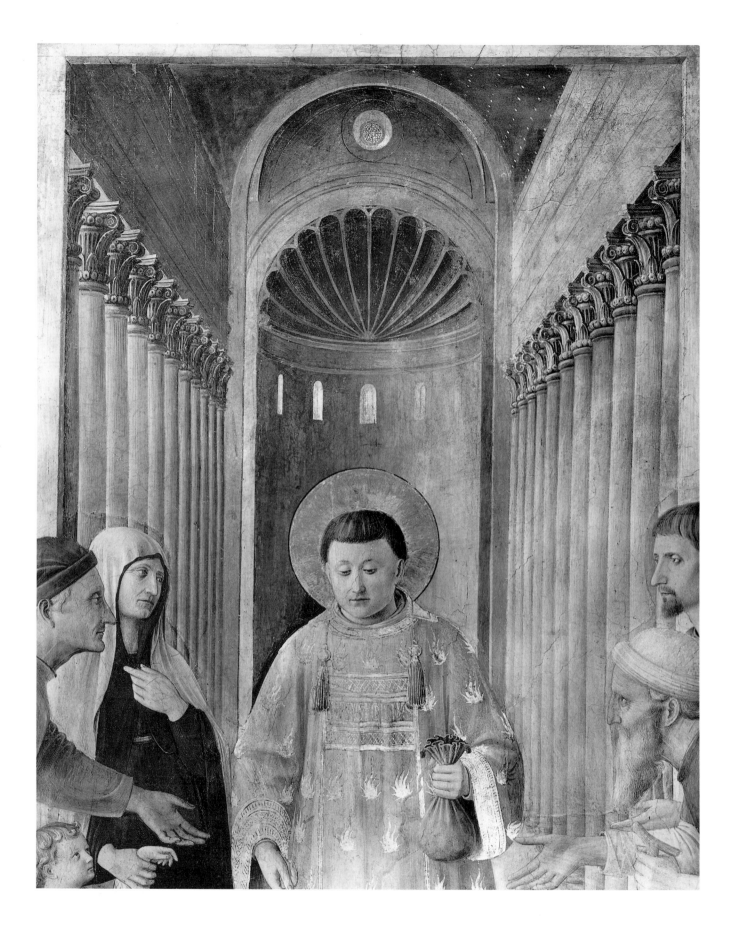

Any consideration of Fra Angelico's last works must include *The Adoration of the Magi*, once in the collection of the Medici, but a work of undetermined date (Plates 46 and 47). It is manifestly a panel by two artists, one of whom can be identified as Filippo Lippi, whilst the other may have been Fra Angelico himself or else a former assistant. The figures of the Virgin and Child, the city wall on the right with the figures alongside it, the floral carpet and some of the figures under the arch on the left are in the manner of Fra Angelico. The rest of the panel appears to be by Filippo Lippi. The circular composition and the swaying, rhythmical pattern of the procession, reinforcing the shape of the panel, are devices frequently employed by artists in the second half of the fifteenth century, and here they are employed in an exploratory way for almost the first time. The advantages of the circular composition become apparent as the eye unravels the wealth of elaborate detail covering the closely worked surface. The circumstances of the commission and of the joint authorship are not known, but whatever the final answer may be, there is a certain justice in the fact that the styles of the two most distinguished painters working in Florence after the death of Masaccio have been perfectly blended in a painting of this quality.

Fig. 10
St Lawrence giving Alms, detail from 'St Lawrence receiving the Treasures of the Church' (Plate 34)
Fresco. Chapel of Pope Nicholas V, Vatican

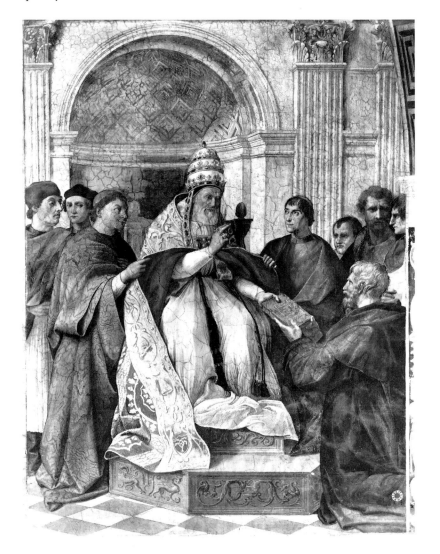

Fig. 11
Raphael:
Gregory IX approving the Decretals of the Church
Fresco. Stanza della Segnatura, Vatican

Outline Biography

c.1395-1400 Born near Florence

1417 Recorded as living in Florence and already active as a painter, but still a layman.

1421 Professed as a monk in this year or slightly before.

1423 Member of the monastic community at San Domenico, Fiesole.

1429 Received payment for an altar-piece painted for the convent of San Pietro Martire, Florence (now in the Museo di San Marco, Florence).

1432 Received payment for a painting of *The Annunciation* for the church of Sant' Alessandro, Brescia (now lost).

1433 Commissioned by the Arte dei Linaiuoli to paint large triptych for their guildhall (now in the Museo di San Marco, Florence).

1437 Probable date of the altarpiece painted for the chapel of San Niccolò dei Guidalotti in the church of San Domenico, Perugia (now in the Galleria Nazionale dell'Umbria, Perugia).

1438 Recorded as active in Cortona.

1441 First mentioned at the convent of San Marco in Florence.

c.1445-9 Recorded in Rome, employed at the Vatican.

1447 Painted part of the vault of the Cappella di San Brizio in the cathedral at Orvieto.

1450 Appointed Prior of San Domenico, Fiesole.

1453/4 Left Fiesole for Rome.

1455 Died in Rome in February and was buried in the church of Santa Maria sopra Minerva.

Select Bibliography

Vasari, G., *Lives of the Most Eminent Painters, Sculptors, and Architects* (translated by G. Bull). Penguin Books, London, 1960. (The passage from Vasari quoted in the text is taken from the first complete English edition, translated by Mrs Jonathan Foster, published in five volumes as part of Bohn's Standard Library between 1855 and 1864).

Pope-Hennessy, J., *Fra Angelico*, 2nd edn. London, 1974.

Baldini, U., *L'opera completa dell'Angelico*. Milan, 1970.

Orlandi, S. (O.P.), *Beato Angelico*. Florence, 1964.

List of Illustrations

Colour Plates

1. King David playing a Psaltery
 c.1430. Pen and brown ink and purple wash on
 vellum, 19.7 x 17.9 cm. British Museum, London

2. The Glorification of St Dominic
 c.1430. Detail from a Missal (No. 558 f. 67 verso).
 Parchment, each leaf 47.5 x 33.7 cm.
 Museo di San Marco, Florence

3. The Conversion of St Paul
 c.1430. Detail from a Missal (No. 558 f. 21).
 Parchment, each leaf 47.5 x 33.7 cm.
 Museo di San Marco, Florence

4. The Virgin and Child Enthroned with Eight
 Angels
 c.1425. Centre panel of an altarpiece.
 Panel, 212 x 237 cm. San Domenico, Fiesole

5. The Virgin and Child Enthroned with
 Twelve Angels
 c.1430-3. Panel, 37 x 28 cm.
 Staedelsches Kunstinstitut, Frankfurt-am-Main

6. The Last Judgement (detail)
 c.1430-3. Panel, 105 x 210 cm.
 Museo di San Marco, Florence

7. The Annunciation
 c.1432-3. Panel, 175 x 180 cm.
 Museo Diocesano, Cortona

8. The Visitation
 c.1432-3. Panel from the predella of *The Annunciation*
 (Plate 7). Panel, 17 x 26 cm.
 Museo Diocesano, Cortona

9. The Presentation of Christ in the Temple
 c.1432-3. Panel from the predella of *The Annunciation*
 (Plate 7). Panel, 17 x 26 cm.
 Museo Diocesano, Cortona

10. The Linaiuoli Triptych
 (with shutters closed):
 St Mark and St Peter
 1433. Panel, 260 x 330 cm.
 Museo di San Marco, Florence

11. The Linaiuoli Triptych
 (with shutters open):
 The Virgin and Child Enthroned with
 St John the Baptist and St Mark
 1433. Panel, 260 x 330 cm.
 Museo di San Marco, Florence

12. The Deposition from the Cross
 c.1433-4. Panel, 176 x 185 cm.
 Museo di San Marco, Florence

13. Detail from 'The Deposition from the
 Cross' (Plate 12)

14. Detail from 'The Deposition from the
 Cross' (Plate 12)

15. Detail from 'The Deposition from the
 Cross' (Plate 12)

16. Detail from 'The Deposition from the
 Cross' (Plate 12)

17. Detail from 'The Deposition from the
 Cross' (Plate 12)

18. The Annunciation
 1450. Fresco, 216 x 321 cm. San Marco, Florence

19. The Coronation of the Virgin
 c.1441-3. Fresco, 189 x 159 cm.
 San Marco (Cell 9), Florence

20. The Virgin and Child Enthroned
 with Four Angels
 1437. Centre panel of an altarpiece.
 Panel, 130 x 77 cm.
 Galleria Nazionale dell'Umbria, Perugia

21. The Virgin and Child Enthroned
 with Four Angels
 c.1435. Centre panel of an altarpiece.
 Panel, 137 x 68 cm. Museo Diocesano, Cortona

22. St Dominic and St Nicholas of Bari
 1437. Side panel from the Perugia altarpiece
 (Plate 20). Panel, 95 x 73 cm.
 Galleria Nazionale dell'Umbria, Perugia

23. St John the Baptist and St Catherine of
 Alexandria
 1437. Side panel from the Perugia altarpiece
 (Plate 20). Panel, 95 x 73 cm.
 Galleria Nazionale dell'Umbria, Perugia

24. The San Marco Altarpiece:
 The Virgin and Child Enthroned with
 Angels and Sts Cosmas and Damian,
 Lawrence, John the Evangelist, Mark,
 Dominic, Francis and Peter Martyr
 c.1440. Panel, 220 x 227 cm.
 Museo di San Marco, Florence

25. The Entombment
 c.1440. Panel from the predella of the San Marco
 altarpiece (Plate 24). Panel, 38 x 46 cm.
 Alte Pinakothek, Munich

26. The Decapitation of St Cosmas and
 St Damian
 c.1440. Panel from the predella of the San Marco
 altarpiece (Plate 24). Panel, 36 x 46 cm.
 Louvre, Paris

27. The Dream of the Deacon Justinian
 c.1440. Panel from the predella of the San Marco
 altarpiece (Plate 24). Panel, 37 x 45 cm.
 Museo di San Marco, Florence

28. The Annunciation
 c.1441-3. Fresco, 187 x 157 cm.
 San Marco (Cell 3), Florence

29. Noli Me Tangere
 c.1441-3. Fresco, 177 x 139 cm.
 San Marco (Cell 1), Florence

30. The Mocking of Christ
 c.1441-3. Fresco, 195 x 159 cm.
 San Marco (Cell 7), Florence

31. The Transfiguration
 c.1441-3. Fresco, 189 x 159 cm.
 San Marco (Cell 6), Florence

32. The Annalena Altarpiece:
 The Virgin and Child Enthroned with
 Sts Peter Martyr, Cosmas and Damian,
 John the Evangelist, Lawrence, and Francis
 c.1445. Panel, 180 x 202 cm.
 Museo di San Marco, Florence

33. St Stephen preaching and St Stephen
 addressing the Council
 c.1447-8. Fresco, 322 x 412 cm.
 Chapel of Pope Nicholas V, Vatican

34. St Lawrence Receiving the Treasures of the
 Church and St Lawrence Distributing Alms
 c.1447-8. Fresco, 271 x 473 cm.
 Chapel of Pope Nicholas V, Vatican

35. St Lawrence before Valerianus
 (left half of St Lawrence before Valerianus
 and The Martyrdom of St Lawrence)
 c.1447-8. Fresco, 271 x 473 cm.
 Chapel of Pope Nicholas V, Vatican

36. The Stoning of St Stephen
 (right half of The Expulsion of St Stephen
 and The Stoning of St Stephen)
 c.1447-8. Fresco, 322 x 236 cm.
 Chapel of Pope Nicholas V, Vatican

37. The Ordination of St Lawrence
 c.1447-8. Fresco, 271 x 197 cm.
 Chapel of Pope Nicholas V, Vatican

38. The Bosco ai Frati Altarpiece:
 The Virgin and Child Enthroned with
 Two Angels between Sts Anthony of Padua,
 Louis of Toulouse, and Francis, and
 Sts Cosmas and Damian and Peter Martyr
 c.1450. Panel, 174 x 174 cm.
 Museo di San Marco, Florence

39. The Coronation of the Virgin
 c.1450. Panel, 213 x 211 cm.
 Louvre, Paris

40. Detail of Plate 39

41. Detail of Plate 39

42. The Vision of Ezekiel
 c.1451. Panel, 39 x 39 cm.
 Museo di San Marco, Florence

43. The Massacre of the Innocents
 c.1451. Panel, 39 x 39 cm.
 Museo di San Marco, Florence

44. The Circumcision
 c.1451. Panel, 39 x 39 cm.
 Museo di San Marco, Florence

45. The Flight into Egypt
 c.1451. Panel, 39 x 39 cm.
 Museo di San Marco, Florence

46. The Adoration of the Magi
 (with Filippo Lippi)
 c.1452-3. Panel, 137.4 cm (diameter).
 National Gallery of Art (Kress collection),
 Washington D.C.

47. Detail from 'The Adoration of the Magi'
 (Plate 46)

48. Christ on the Cross with the Virgin
 and St John the Evangelist Adored
 by a Dominican Cardinal
 c.1450-5. Panel, 88 x 36 cm.
 Fogg Art Museum, Cambridge, Massachusetts

Text Figures

1. Tomb-slab of Fra Angelico
 Santa Maria sopra Minerva, Rome.

2. The Presentation in the Temple
 c.1441-3. Fresco, 151 x 131 cm.
 San Marco (Cell 10), Florence.

3. The Lamentation over the Dead Christ
 1436. Panel, 105 x 164 cm. San Marco, Florence.

4. Sassetta:
 The Wish of the Young St Francis to
 become a Soldier
 1437-44. Panel, 87 x 52.4 cm.
 National Gallery, London.

5. The Ordination of St Stephen and
 St Stephen distributing Alms
 c.1447-8. Fresco.
 Chapel of Pope Nicholas V, Vatican.

6. Rogier van der Weyden:
 The Deposition from the Cross
 Before 1443. Panel, 220 x 262 cm. Prado, Madrid.

7. Lorenzo Ghiberti:
 Detail from 'David returning to Jerusalem
 with the Head of Goliath'
 Bronze panel. Second door of the Baptistery,
 Florence.

8. Detail from 'The Coronation of the Virgin'
 (Plate 39)
 Louvre, Paris.

9. Six Scenes from the Life of Christ
 c.1451. Panel, each 39 x 39 cm.
 San Marco, Florence.

10. St Lawrence giving Alms, detail from
 'St Lawrence receiving the Treasures of the
 Church' (Plate 34)
 Fresco. Chapel of Pope Nicholas V, Vatican.

11. Raphael:
 Gregory IX approving the Decretals of
 the Church
 Fresco. Stanza della Segnatura, Vatican.

Comparative Figures

12. Saints and Beati of the Dominican Order
 c.1424-5. A predella panel of the San Domenico altarpiece, at Fiesole. National Gallery, London

13. The Annunciation
 c.1430. Detail from a Missal (No. 558 f. 33 verso). Museo di San Marco, Florence

14. Lorenzo Ghiberti:
 Jacob and Esau
 c.1435. Panel of the second Baptistery door, Florence

15. The Expulsion of Adam and Eve
 Detail from Plate 7

16. The Adoration of the Magi
 c.1432-3. A predella panel of the Cortona altarpiece. Museo Diocesano, Cortona

17. Masaccio:
 Madonna and Child with St Anne
 Uffizi, Florence

18. Lorenzo Ghiberti:
 St Stephen
 1420. Or San Michele, Florence

19. Detail from Plate 12

20. Lorenzo Ghiberti:
 Detail from the Reliquary of St Zenobius
 1434-42. Cathedral, Florence

21. St Nicholas addressing an Imperial Emissary, and saving a Ship at Sea
 1437. A predella panel of the Perugia altarpiece. Pinacoteca Vaticana, Rome

22. The Birth and the Vocation of St Nicholas and St Nicholas and the Three Maidens
 1437. A predella panel of the Perugia altarpiece. Pinacoteca Vaticana, Rome

23. Detail from Plate 24

24. Detail from Plate 29

25. Detail from Plate 31

26. Virgin and Child Enthroned with Eight Saints
 c.1450. San Marco, Upper Corridor, Florence

27. Detail from Plate 34

28. St Lawrence before Valerianus;
 the Martyrdom of St Lawrence
 c.1447-8. Chapel of Pope Nicholas V, Vatican

29. The Expulsion of St Stephen;
 the Stoning of St Stephen
 c.1447-8. Chapel of Pope Nicholas V, Vatican

30. St Stephen and St Peter, detail of The Ordination of St Stephen
 c.1447-8. Chapel of Pope Nicholas V, Vatican

31. The Attempted Martyrdom of Sts Cosmas and Damian by Fire
 c.1440. A predella panel of the San Marco altarpiece. National Gallery of Ireland, Dublin

32. The Presentaion in the Temple
 c.1451. Museo di San Marco, Florence

33. The Annunciation
 c.1451. Museo di San Marco, Florence

34. St Peter
 c.1450-5. Private collection.

The Plates

1 King David playing a Psaltery

c.1430. Pen and brown ink and purple wash on vellum, 19.7 x 17.9 cm.
British Museum, London

In the reformed Dominican communities such as Angelico's own, San Marco, it is known that manuscript illumination was encouraged and practised. There is only one volume in which extensive work can safely be attributed to him, and that is the Missal number 558 at San Marco. This drawing of *King David playing a Psaltery* appears to be closely related in style to the work in Missal 558. David sits awkwardly, at the base of a throne on a seat, plucking at the strings of his psaltery. The depiction of the plinth, panelling, entablature and other details of the architecture on which he rests, suggests that this drawing dates from the same period as the San Marco Missal, but there can be no certainty that it was actually intended as a sketch or preparatory drawing for a manuscript illumination. The solidity and depth of parts of the draperies hint at the modelling of which Angelico was capable.

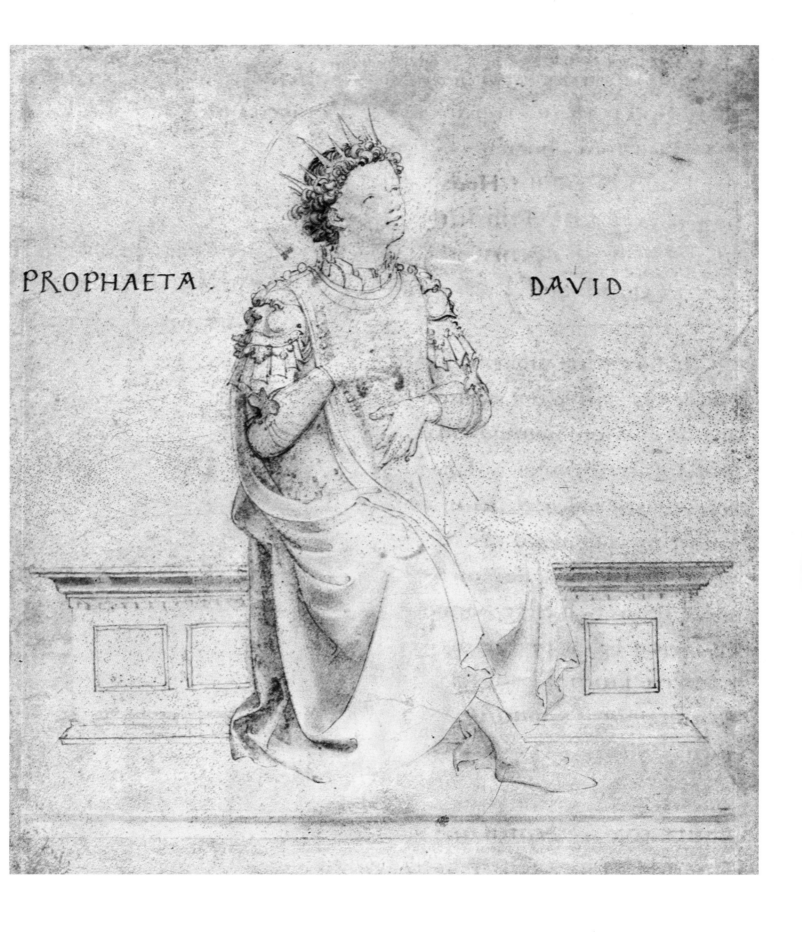

PROPHAETA . DAVID

The Glorification of St Dominic

c. 1430. Detail from a Missal (No. 558 f. 67 verso). Parchment, each leaf 47.5 x 33.7 cm. Museo di San Marco, Florence

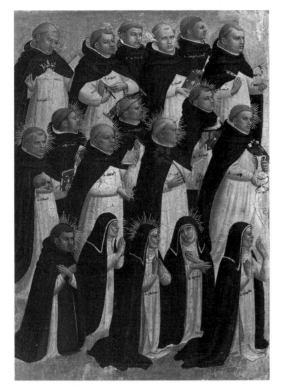

Fig. 12
Saints and Beati
of the Dominican
Order

c.1424-5. A predella panel
of the San Domenico
altarpiece, at Fiesole.
National Gallery, London

Some eighteen pages of the San Marco Missal 558 bear illuminations by Angelico's hand and a further eleven those by other members of his workshop. St Dominic, the founder of the Order of Preachers, stands within a golden mandorla (oval panel) in the habit of a Dominican, eight angels surrounding him, the four uppermost glorifying him in music. Below the mandorla to the right are the saint's iconographic emblems: the star and the dog with a torch in its mouth, here shown as a jet of flame. The solid modelling of St Dominic is repeated in the sculptural qualities of the four saints who appear in the roundels sprouting out of the initial I. In the fifth roundel St Dominic is shown greeting his contemporary, St Francis of Assisi. Overall, this work on vellum is carried out with the minimum concession to the linear traditions of manuscript illumination. Angelico grants this work a similar weight of treatment to his painting on panel at this date, as a comparison with the predella panels of the San Domenico altarpiece shows (Fig. 12).

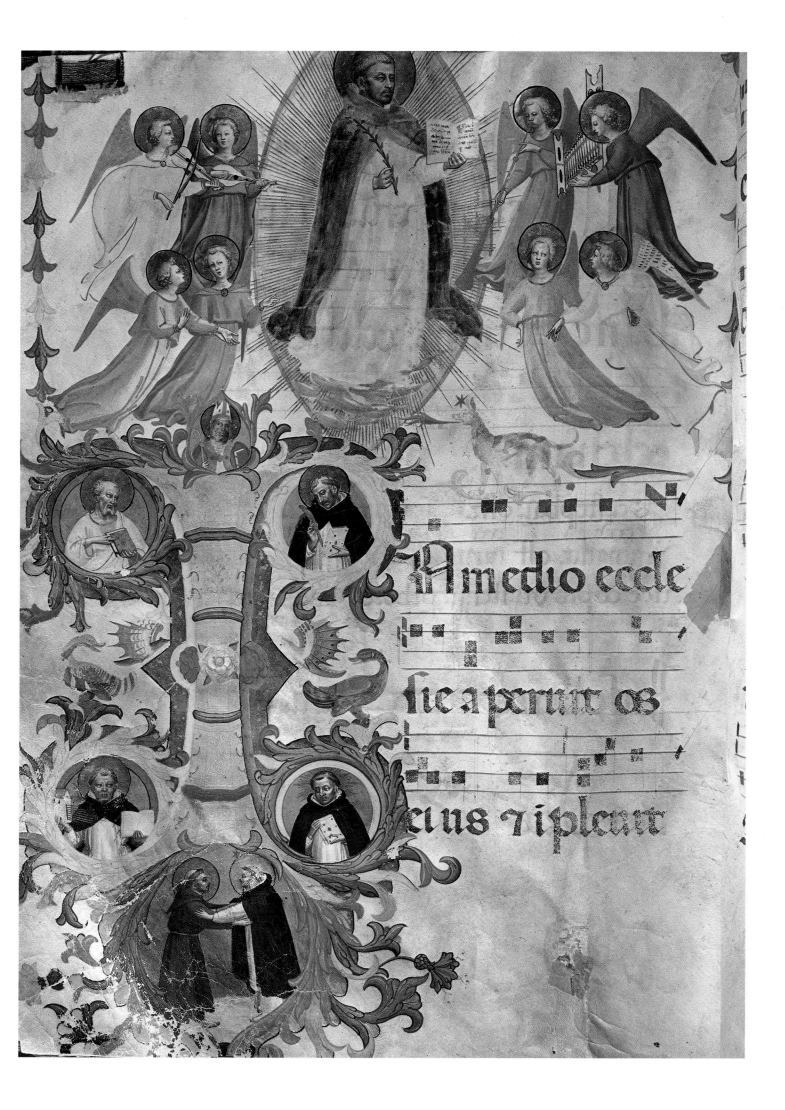

c. 1430. Detail from a Missal (No. 558 f. 21). Parchment, each leaf, 47.5 x 33.7 cm. Museo di San Marco, Florence

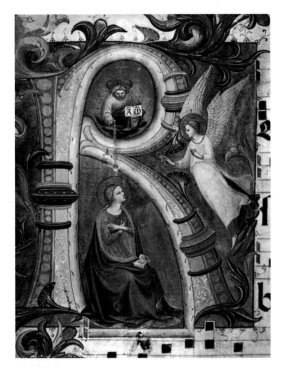

Fig. 13
The Annunciation

c.1430. Detail from a
Missal (No. 558 f. 33 verso).
Museo di San Marco,
Florence

The scene depicted is described in the Acts of the Apostles. A light from heaven appears to Paul and the voice of Christ asks why He is persecuted by him. Paul is shown here lying on the ground, in a rather unrealistically relaxed pose, with Damascus, his destination, in the background represented as a town wall of simple geometric forms rendered in ambigious perspective. A cross-shaped halo identifies the foreshortened figure in the mandorla as Christ. The astonishment of Paul's companions who 'stood speechless, hearing a voice but seeing no man' (Apostles 9, v.7), is dramatically and economically portrayed.

In the illumination of *The Annunciation* in the same missal (Fig. 13) Angelico, deprived of a clear and unencumbered patch of vellum on which to create his scene, ignores the implied restrictions of space imposed upon him by the initial R. The Virgin looks out from under the arch of the letter at the angel who is placed slightly forward of the initial. Above, God the Father drops the Holy Ghost by golden threads through or over the letter, to hover above her head.

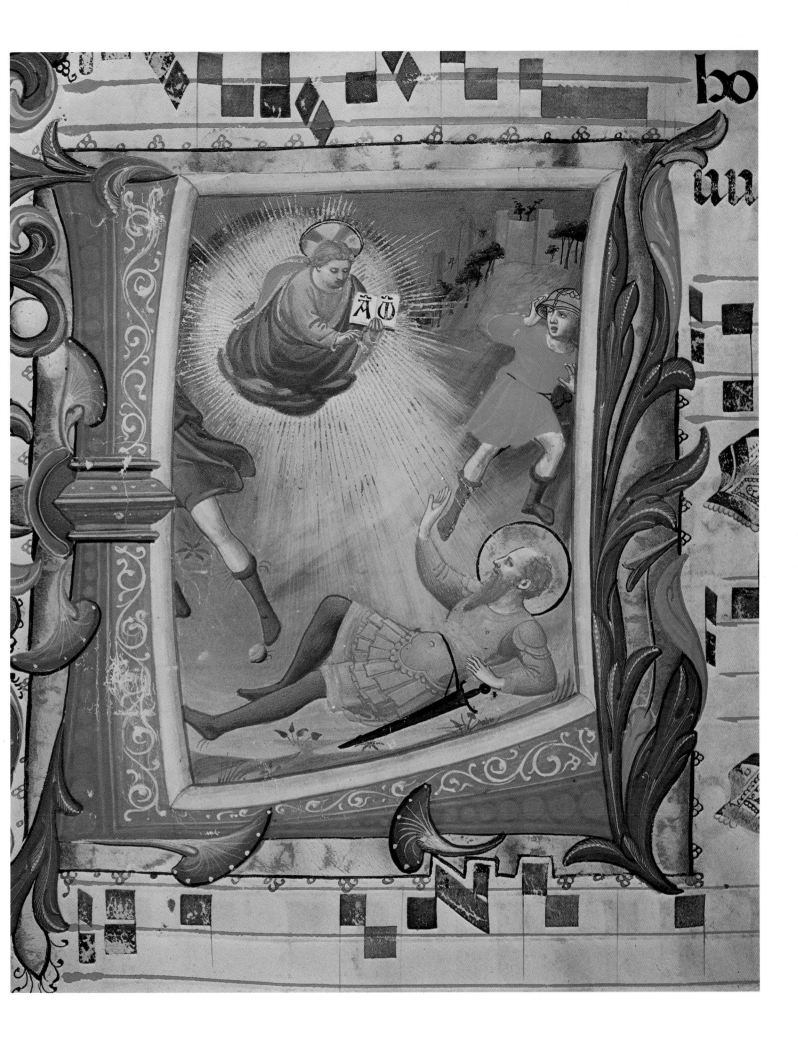

4 The Virgin and Child Enthroned with Eight Angels

c.1425. Centre panel of an altarpiece. Panel, 212 x 237 cm. San Domenico, Fiesole

This is the centre panel of a triptych painted for the altar of the church of San Domenico at Fiesole, just outside Florence. Three-quarters of a century after its completion, the background was repainted by Lorenzo di Credi to show a contemporary architectural backdrop set in front of a landscape. Angelico's picture space is defined in part by the tiled floor at the foot of the panel. In the two side panels the lines of floor stretch in towards the centre point at sharper angles. The eight angels in front, beside, and behind her create the space in which the Virgin sits. A similar circular arrangement of angels in Ghiberti's window of 1405 of *The Assumption of the Virgin* for Florence cathedral shows Angelico's debt to his elder contemporary. The Virgin's gown falls in a restrained manner, her head inclined to one side. The plump cheeks and closely curled hair of Christ and the angels owe much to the manner of Gentile da Fabriano, exponent of the fourteenth-century International Gothic style, who was the dominant painter in Florence during his stay there from 1422 to 1425/6.

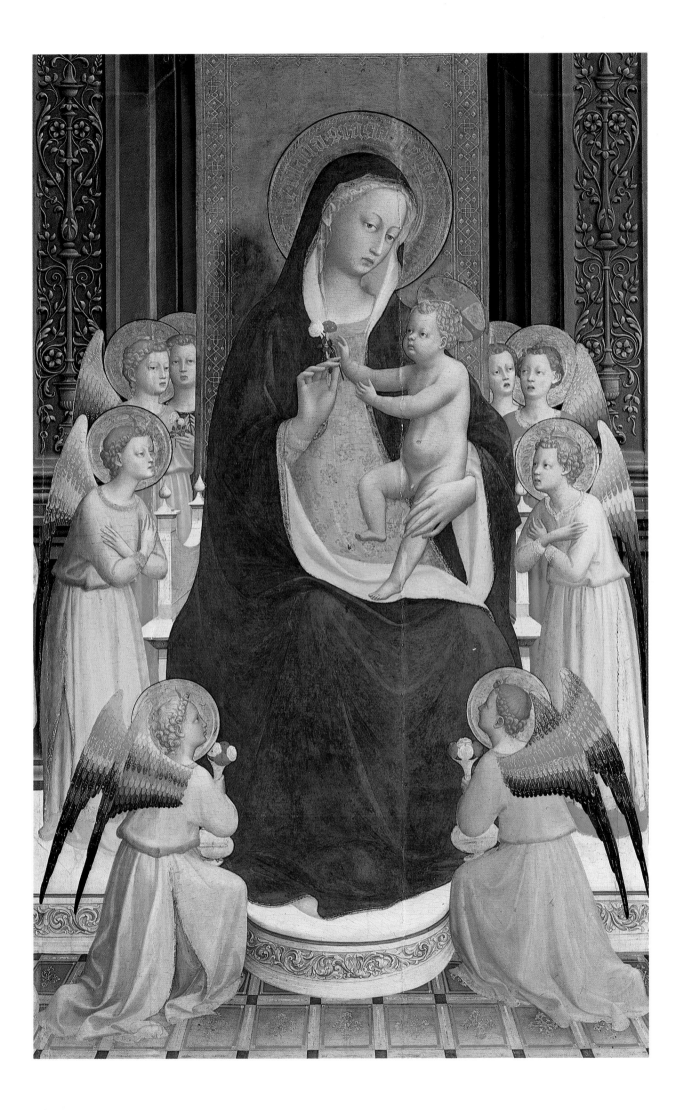

5 The Virgin and Child Enthroned with Twelve Angels

c.1430-3. Panel, 37 x 28 cm. Staedelsches Kunstinstitut, Frankfurt-am-Main

Here Angelico shows an increasing command of space and an equal interest in its depiction. The same methods of creating space – the receding rectangle and the ring of angels – are employed in this work as in the panel with the Virgin and eight angels (Plate 4), but here Angelico has added a carefully rendered, elegant throne raised over three steps, which fills the greater part of the panel and produces a bold spatial statement. Its top takes the form of a hexagonal cupola, but this still has chiefly pointed arches and cannot be said to represent the architectural avant-garde of the time. Compared with his later depictions of architecture it lacks monumentality. There is no attempt to extend the picture space into the far distance or to heighten the realism further, as the background of the panel is rendered in plain gold in the trecento fashion.

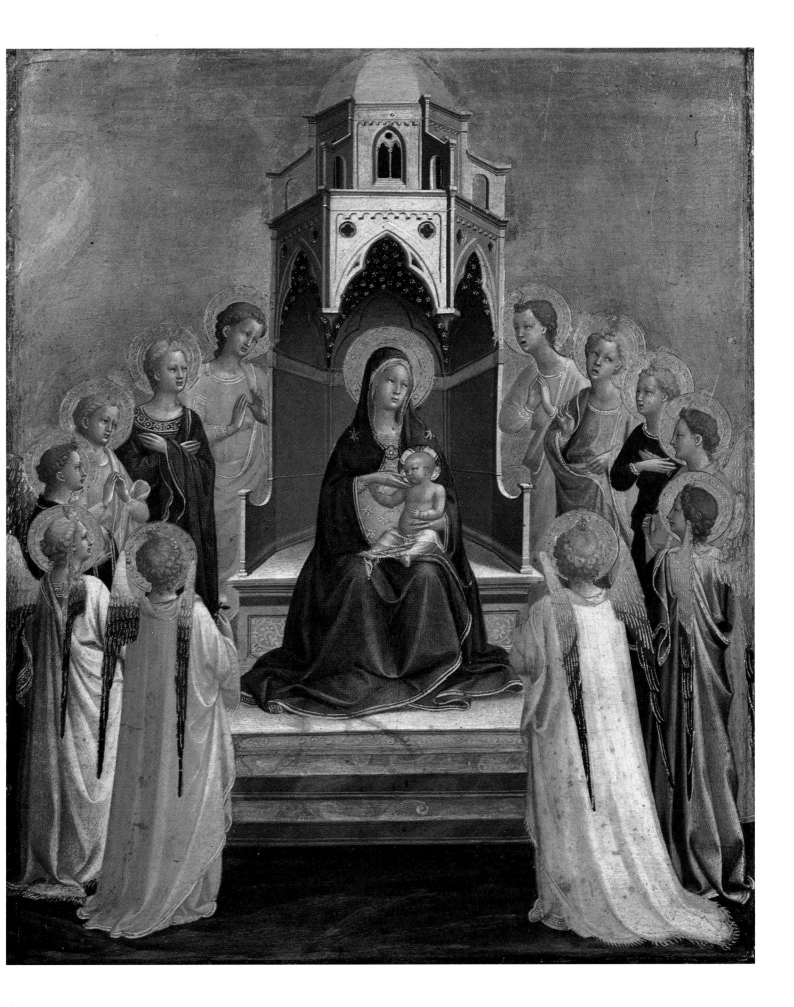

The Last Judgement (detail)

c.1430-3. Panel, 105 x 210 cm. Museo di San Marco, Florence

The large receding rectangle of empty tombs creates the depth in the bottom half of this picture. An empty sarcophagus laid across it in the foreground subtly reduces the emphasis on this axis. Originally forming part of a seat, the complete picture extends to either side to show paradise and hell, but these scenes are thought to be by Angelico's workshop. Beside the empty tombs stand the judged; the saved with radiant heads exit left to paradise; and demons drive the nimbus-less damned to the right, down to hell. When painting the damned, Angelico may have had in mind the panel by Ghiberti, *Christ Driving the Money Lenders from the Temple*, on the first bronze door of the Baptistery in Florence as there are marked similarities between the images. The strong perspectival device of the receding rectangle leading the eye to the horizon and an empty sky, used here by Angelico, is also employed by Ghiberti in the centre of his Jacob and Esau panel in the second door of the Baptistery (Fig. 14). In the upper part of the panel Christ sits in judgement in a mandorla framed by a border of angels. On his right is the Virgin and on his left St John the Baptist. Beyond them on each side are two tiers of seated apostles and saints. The spatial depth of the terrestrial part of the picture is not maintained in the celestial half, the slight angling of the two banks of saints failing to give heaven the same illusion of depth.

Fig. 14
Lorenzo Ghiberti:
Jacob and Esau

c.1435. Panel of the
second Baptistry door,
Florence

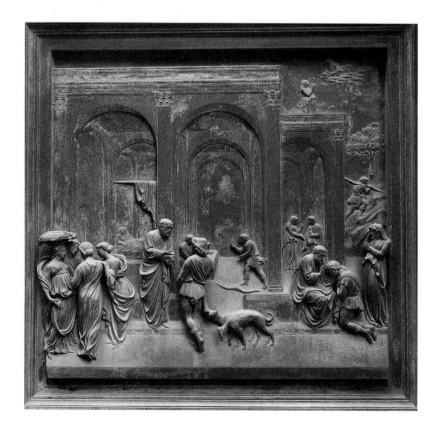

7 The Annunciation

c.1432-3. Panel, 175 x 180 cm. Museo Diocesano, Cortona

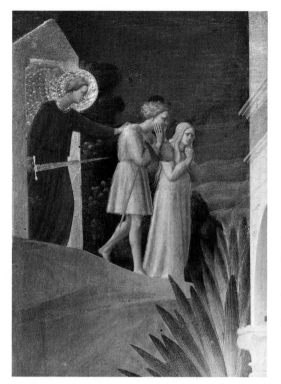

Fig. 15
The Expulsion of
Adam and Eve
Detail from Plate 7

In a loggia of columns and arches reminiscent of those in Brunelleschi's Foundling Hospital in Florence, the angel appears to Mary. Shown in profile, he occupies the larger part of the painting, his richly painted wings extending out through the colonnade, their upper tips marking the centre of the picture. He declaims to the Virgin, 'the Holy Ghost shall come upon thee, and the power of the highest shall overshadow thee' (Luke 1, v. 35). She, demure, with a dove fluttering above her head in a burst of golden light, inclines towards him and responds, 'Behold the handmaid of the Lord; be it unto me according to thy word' (Luke 1, v. 38). Beyond them the picture space extends into the Virgin's chamber, and further, hidden space is hinted at by the bed curtain there which serves also to set off Gabriel's nimbus. Outside the loggia is a delicately painted garden, enclosed by a palisade, symbolic of Mary's virginity. Carved in a roundel above the centre column is a half-length effigy of Isaiah, who had prophesied the birth of a child to a virgin. The pink entablature of the loggia points to the second reference to the Old Testament, in the top left corner, where Adam and Eve are expelled from Paradise (Fig. 15) – a fitting parallel in a picture showing the first announcement of the coming birth of mankind's Redeemer.

Undoubtedly Angelico's first truly great painting, this *Annunciation* formed a prototype for a noble line of derivatives.

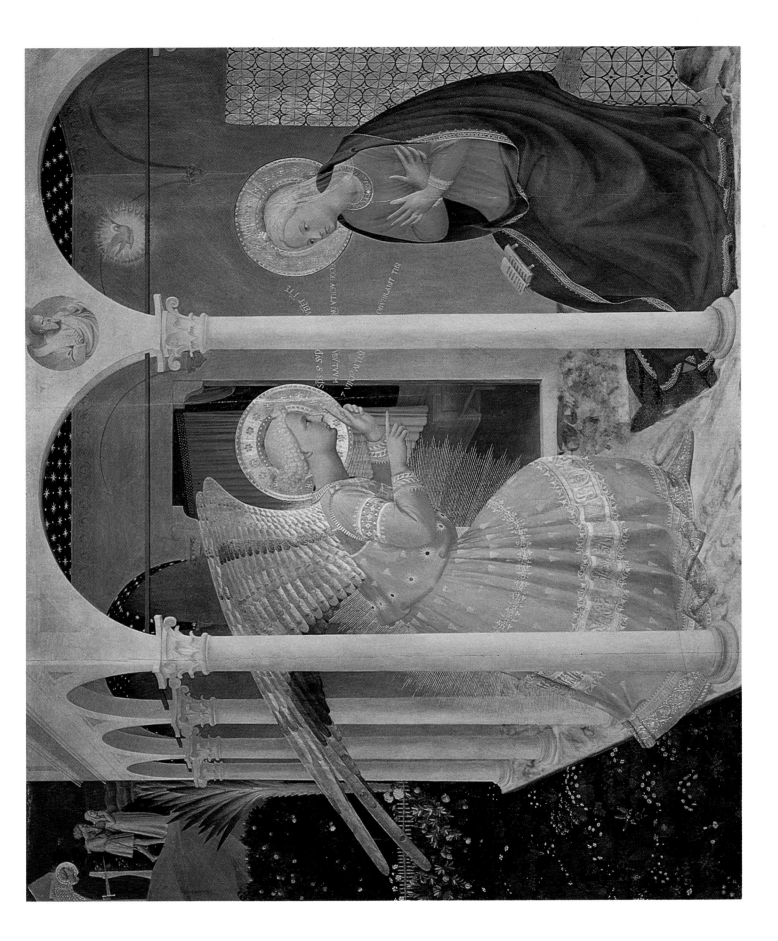

The Visitation

c.1432-3. Panel from the predella of *The Annunciation* (Plate 7). Panel, 17 x 26 cm. Museo Diocesano, Cortona

The Cortona *Annunciation* has seven panels in the predella. Five show scenes from the life of the Virgin and two from the life of St Dominic. The event shown here is described in the Gospel of Luke. Immediately following the Annunciation, Mary 'went into the hill country with haste, into a city of Juda; and entered into the house of Zacharias, and saluted Elisabeth' (Luke 1, v. 39-40). The Virgin and Elisabeth embrace, the straight folds of their gowns showing a simplicity and reserve alien to the curvilinear trecento influences of some of Angelico's mentors and contemporaries. Elisabeth, six months pregnant with John the Baptist, is given a wider girth than her cousin. Juda is represented by a series of simple, geometric forms, sharply lit but slightly thin and awkward. A woman makes her way up the hill path which lies in shadow below her. Behind her the sky and earth meet in the haze of a Tuscan summer. This is the first identifiable landscape in Italian art. In the middle distance a lake, which no longer exists, spreads out in the Chiana Valley; beyond rises the town of Castigliona Fiorentino, and further distant the tower of Monterchi.

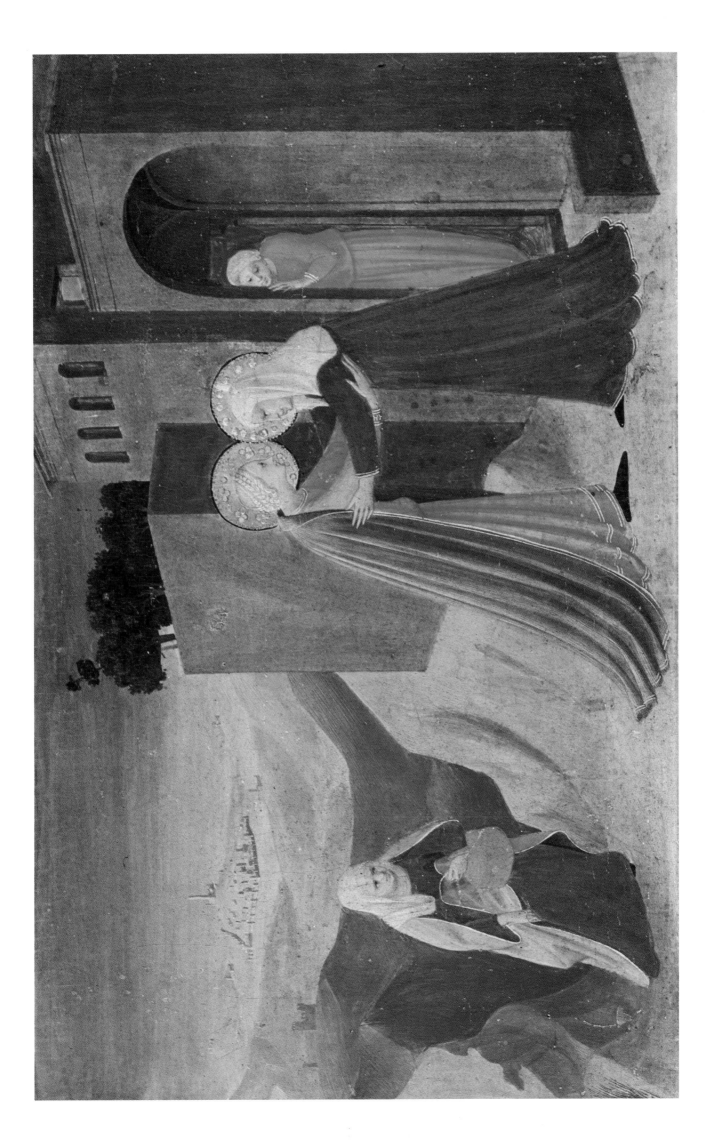

c.1432-3. Panel from the predella of *The Annunciation* (Plate 7). Panel, 17 x 26 cm. Museo Diocesano, Cortona

Fig. 16
The Adoration of the Magi

c.1432-3. A predella panel of the Cortona altarpiece. Museo Diocesano, Cortona

In this, another predella panel from the Cortona altarpiece, Joseph, the Virgin, the High Priest and St Anne stand in the foreground, a nave of receding columns extending backwards behind them. Exterior space is hinted at by the doorway to the left, the round window in the apse, the edge of the top light high above the nave and the strong light hitting the foreground from a source outside the picture space. The architecture bears a rudimentary similarity to Brunelleschi's church of Santo Spirito in Florence, of 1434 or later, but it completely lacks its monumentality. The depiction of wall and column here has the same thinness as in the buildings of Juda in *The Visitation* (Plate 8), and the throne and cupola in the *Virgin and Child Enthroned with Twelve Angels* (Plate 5). From this point onwards Angelico's rendering of buildings was to grow steadily more robust. *The Adoration of the Magi* (Fig. 16) is another predella panel from the Cortona altarpiece. Pope-Hennessy argues that the 'frieze-like' composition of this panel, with all those coming to adore the new-born Christ strung out on roughly the same plane, is less sophisticated than the circular composition in the same scene in the Linaiuoli altarpiece (Plates 10 and 11), and is evidence to support the theory that the Cortona *Annunciation* pre-dates the work for the Linaiuoli.

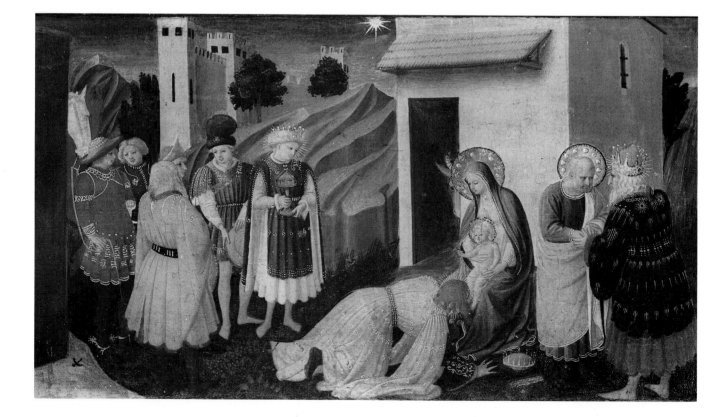

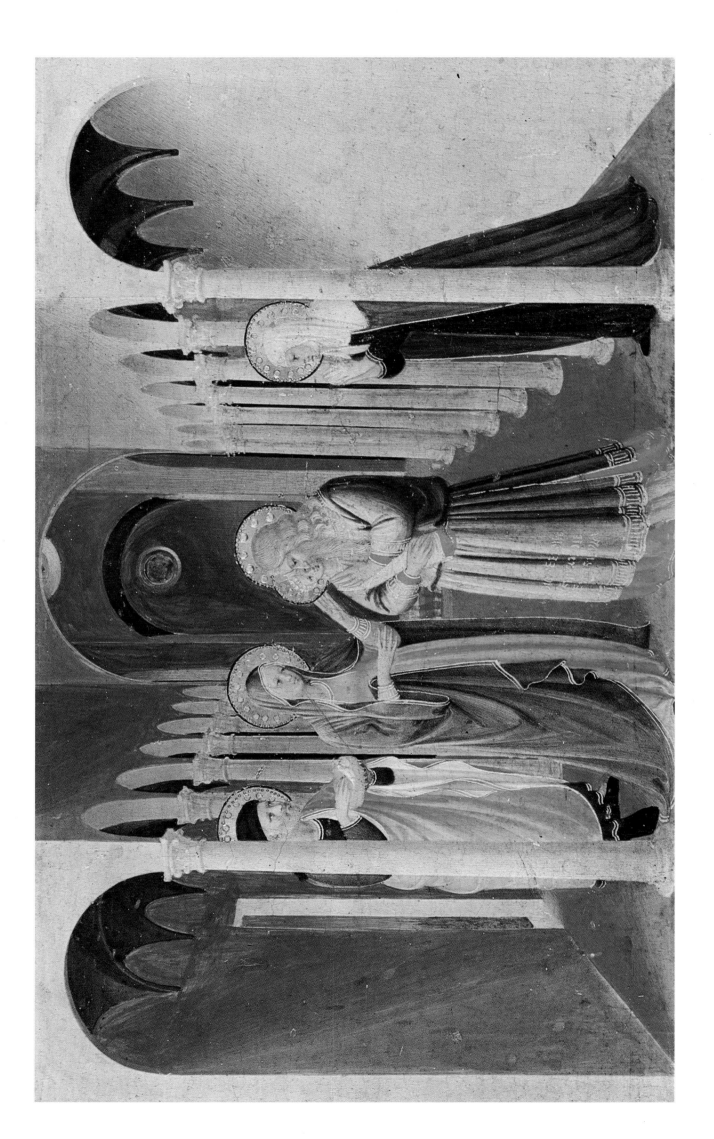

The Linaiuoli Triptych (with shutters closed): St Mark and St Peter

1433. Panel, 260 x 330 cm. Museo di San Marco, Florence

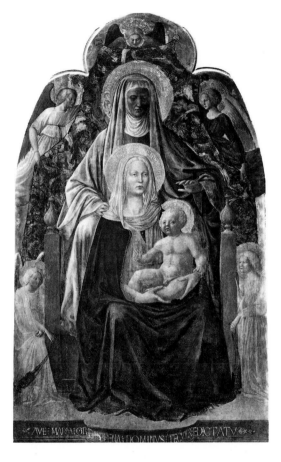

Fig. 17
Masaccio:
Madonna and Child
with St Anne

Uffizi, Florence

The Arte de' Linaiuoli, the Guild of Linen Manufacturers, commissioned this altarpiece from Angelico in 1432, for the Residenza of the Guild in the Piazza Sant' Andrea in Florence. The agreed price was 'one hundred and ninety gold florins for the whole and his craftsmanship, or as much less as his conscience shall deem it right to charge'. The mammoth frame, 17 feet high and 8 feet 10 inches wide, was designed by Ghiberti and executed by three craftsmen in his workshop. It is firmly classical, with round arch, dental cornice, and pediment. On the outside of the doors are two monumental and statuesque figures: *St Mark and St Peter*. Both stand on flat but irregularly edged rocks. The background is dark and unarticulated: there is no attempt to claim it for the picture space. St Mark's lion crouches behind his right leg. The angle between the saint's feet, and the foreshortening of the book he holds, establish his distance from the picture surface. St Peter holds his key and gazes heavenwards. Angelico has shed some of the restraint of earlier work and eveloped the two saints in garments falling in rich folds. But these folds are not so sinuous that they compromise Angelico's attempts at realism. They provide a degree of volume and weight which makes these painted figures comparable with some of Ghiberti's statues of this date, such as his *St Matthew*, commissioned by the Guild of Bankers for a niche on the outside of the church of Or San Michele in Florence, and completed in 1420.

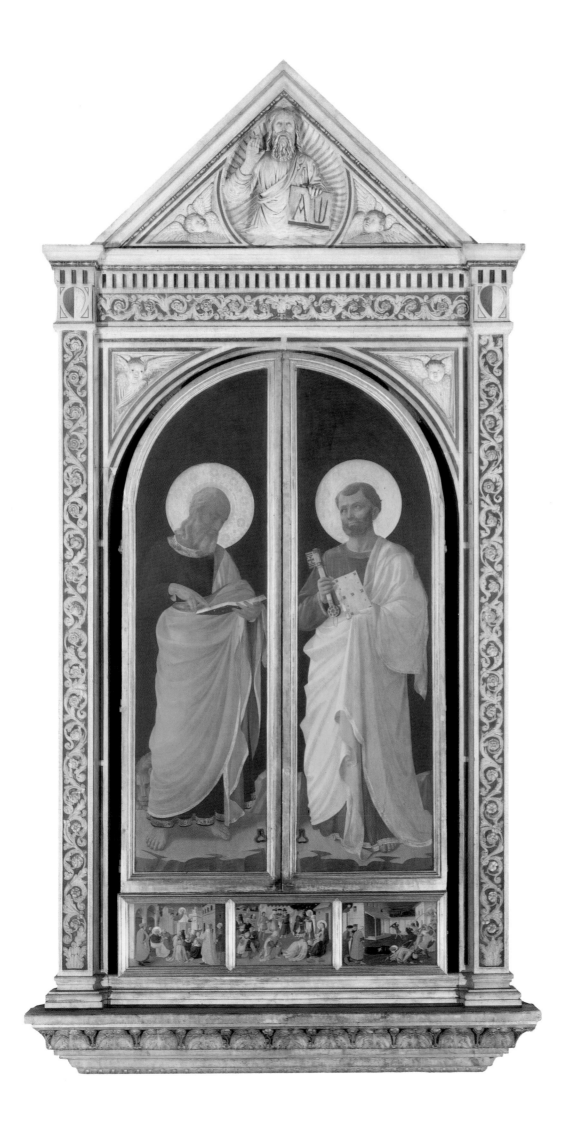

11

The Linaiuoli triptych (with shutters open): The Virgin and Child Enthroned with St John the Baptist and St Mark

1433. Panel, 260 x 330 cm. Museo di San Marco, Florence

The doors of the triptych open to reveal the *Virgin and Child Enthroned with St John the Baptist and St Mark*. The two saints have the same three-dimensional qualities as their companions on the outside of the triptych. St John the Baptist is shown with his right arm curved round and up across his chest and left shoulder, and the top of his cross pushed back away from the viewer. The right foot is to the fore. The stance and treatment of this figure is extremely close to Ghiberti's statue of St Matthew. Likewise Angelico's painting of *St Mark* on the Virgin's right is equally close to Ghiberti's statue of *St Stephen* of 1427 also on Or San Michele (Fig. 18). In both cases the extended hand draws the eye into the space occupied by the figure. The central panel of *The Virgin and Child* differs from its predecessors in Angelico's oeuvre in the absence of a circle of space-defining angels. Greater realism is achieved by translating part of the traditional gold background into elaborate golden curtains which frame the Virgin, the outline thus created echoing a pointed arch. She has the same solidity and three-dimensional qualities as the saints in the work. The Child is clothed and stands upright holding His arms out in blessing. He lacks the overtly puerile qualities of many infant Christ's of the renaissance and as a result appears medieval or Byzantine.

Fig. 18
Lorenzo Ghiberti:
St Stephen

1420. Or San Michele,
Florence

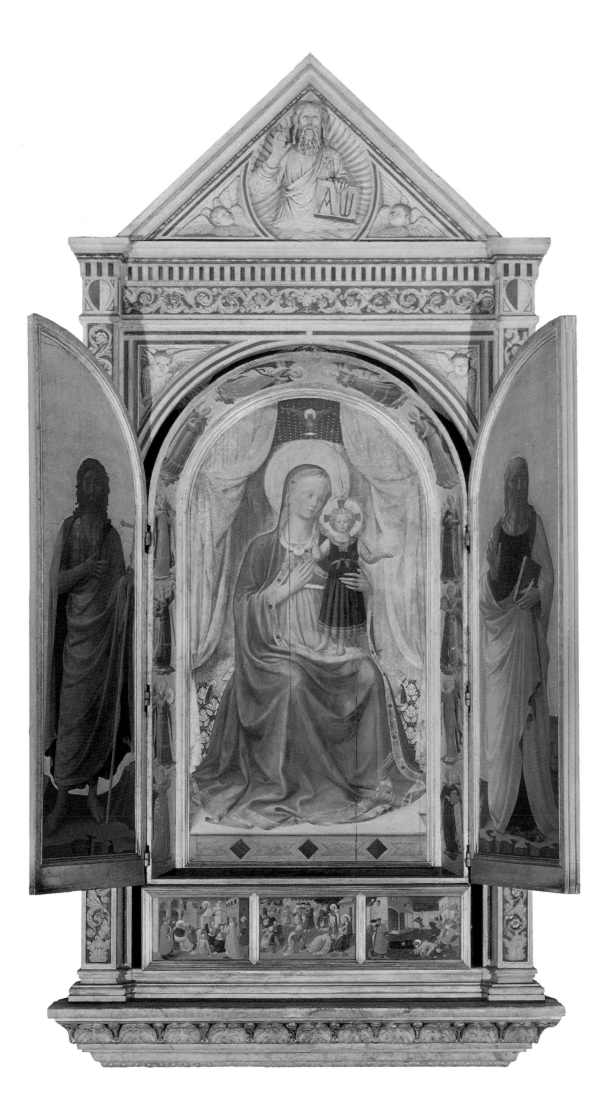

The Deposition from the Cross

c.1433-4. Panel, 176 x 185 cm. Museo di San Marco, Florence
54

This work was originally commissioned by Palla Strozzi from Lorenzo Monaco, for the sacristy of the church of Santa Trinita in Florence, but by the time of Monaco's death only the pinnacles of this work had been painted. When Angelico took over the commission he found himself cribbed and confined by Monaco's ready-made triple-arched Gothic frame. He ignored these constraints, however, making skilful use of the three arches in his composition to provide a scene of stunning beauty and subdued yet poignant emotion, set in an expansive Tuscan landscape. Although the work is painted on one panel, the three arches of the frame find an echo in the placing of the figures in three groups. The central arch is largely blocked off by the wooden framework of the cross and two ladders. The cross bar of the former appears to run behind the picture frame hinting at further, obscured space. With no scene behind but the sky and the lattice work of timber, the eye is drawn to the body of Christ which is at the very centre of the picture. Angelico challenges the tendency of the other two arches to define the shape and space of the work by placing a strong vertical, in the form of a tower or a tree, in the corners of each. The pilasters on either side of the frame contain twelve panels with full length portraits of saints, and eight medallions with portrait busts. The full-length figures are shown standing on columns which are each painted with careful attention to the view-point of the spectator.

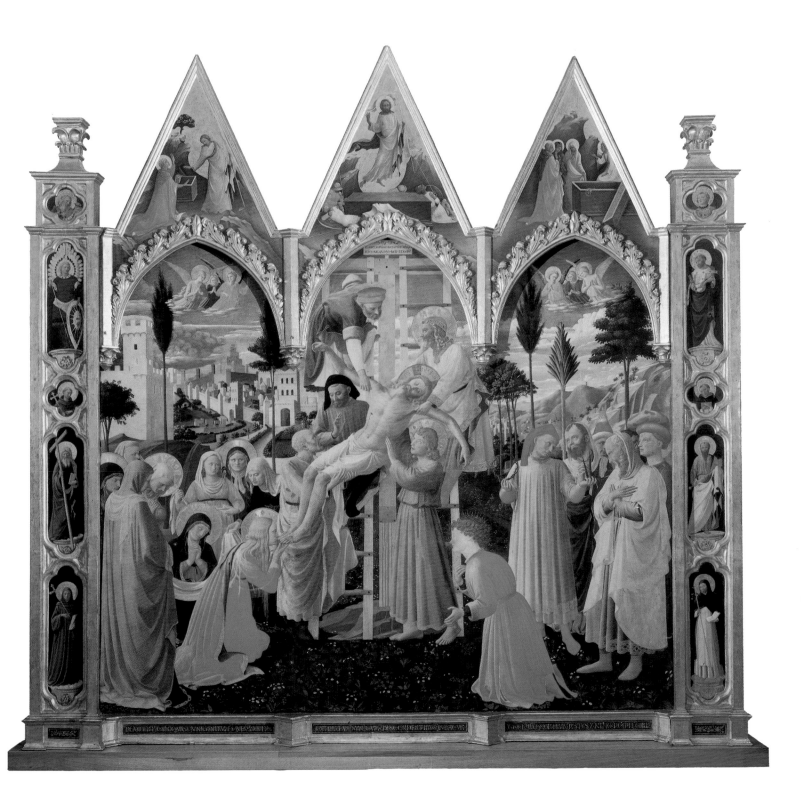

13

Detail from 'The Deposition from the Cross' (Plate 12)

The cross has no upper limb, thereby blunting the pointedness of the arch behind which it stands. There is room at the top only for a view of the mocking panel which declares Christ King of the Jews. The vertical emphasis comes not just from the cross and the two ladders but from the arm of the top left figure, and from the upright stance of St John at the bottom right. Joseph of Arimathea and Nicodemus gently lower Christ's body, his arms and legs lying in diagonals across the timber grid behind Him. He is covered with the weals of the flagellation, and blood trickles from the lance wound in his side. More blood runs down the cross to the rock at the base, a stylized representation of Golgotha. Christ's head lies almost horizontally, his passive face marked only by thin dribbles of blood from the pricks of the crown of thorns. Vasari claims that one of the figures lowering Christ is a portrait of Michelozzo, the architect responsible for the rebuilding of the convent of San Marco in Florence. Pope-Hennessy suggests that if he is represented at all it is in the figure under Christ's right arm wearing a black *cappucio*, or monastic hood.

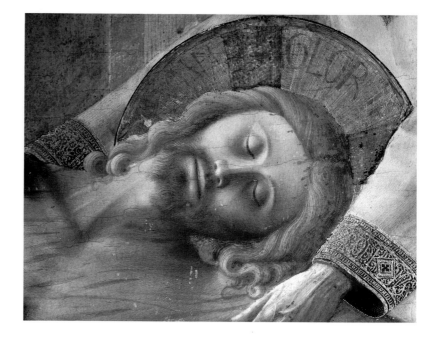

Fig. 19
Detail from
Plate 12

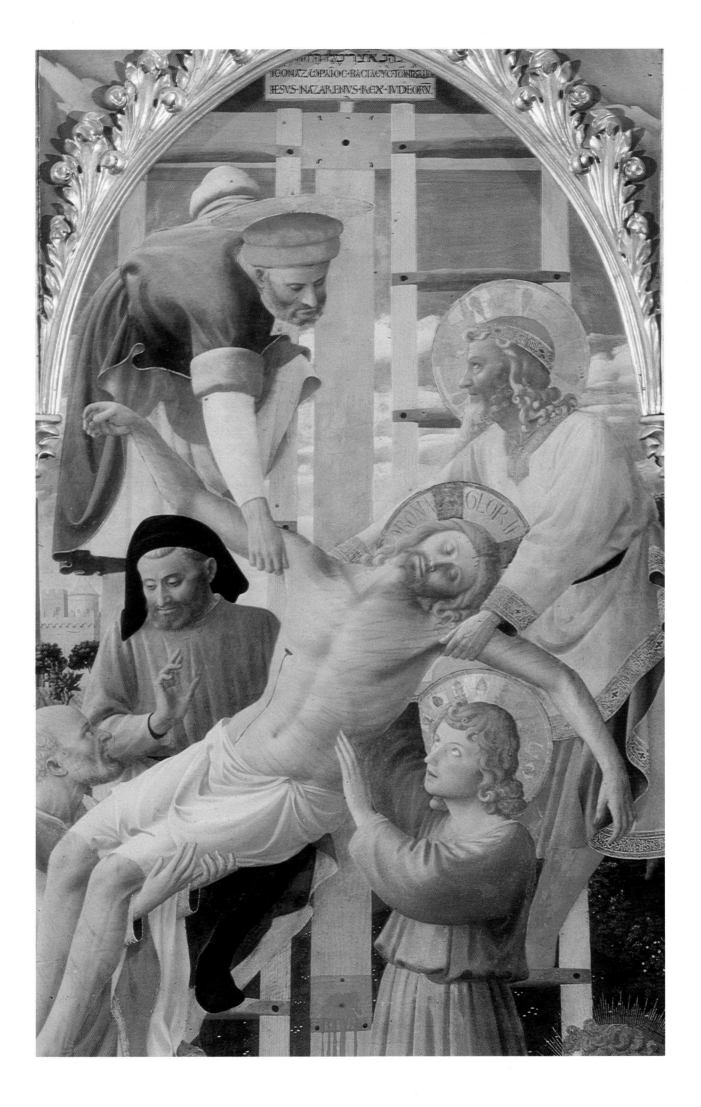

Detail from 'The Deposition from the Cross' (Plate 12)

In the distance at the top left of *The Deposition* lies Jerusalem, shown by Angelico as a sparkling Tuscan hill town. The city fortifications appear as a series of cubes, pillars, and walls massed together in a sharply defining light. The thin, tentative rendering of buildings seen in *The Virgin and Child Enthroned with Twelve Angels* and *The Presentation in the Temple* has disappeared, to be replaced by a solid and monumental architecture. Buildings of widely varying sizes, shapes and colours are arranged together within the city walls. At the top of the hill rises a citadel-like temple. Outside the city gates lies a landscape of ploughed fields, farmhouses, and hedgerows. In the sky, above a storm cloud is gathering which throws shadow over half the city. The whole is viewed through a screen of trees, which mark out the middle distance in the complete picture.

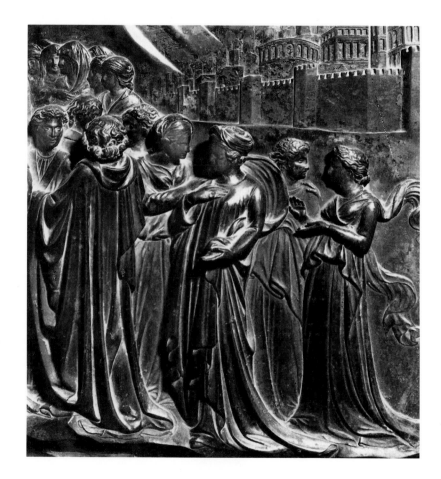

Fig. 20
Lorenzo Ghiberti:
Detail from the
Reliquary of
St Zenobius

1434-42. Cathedral,
Florence

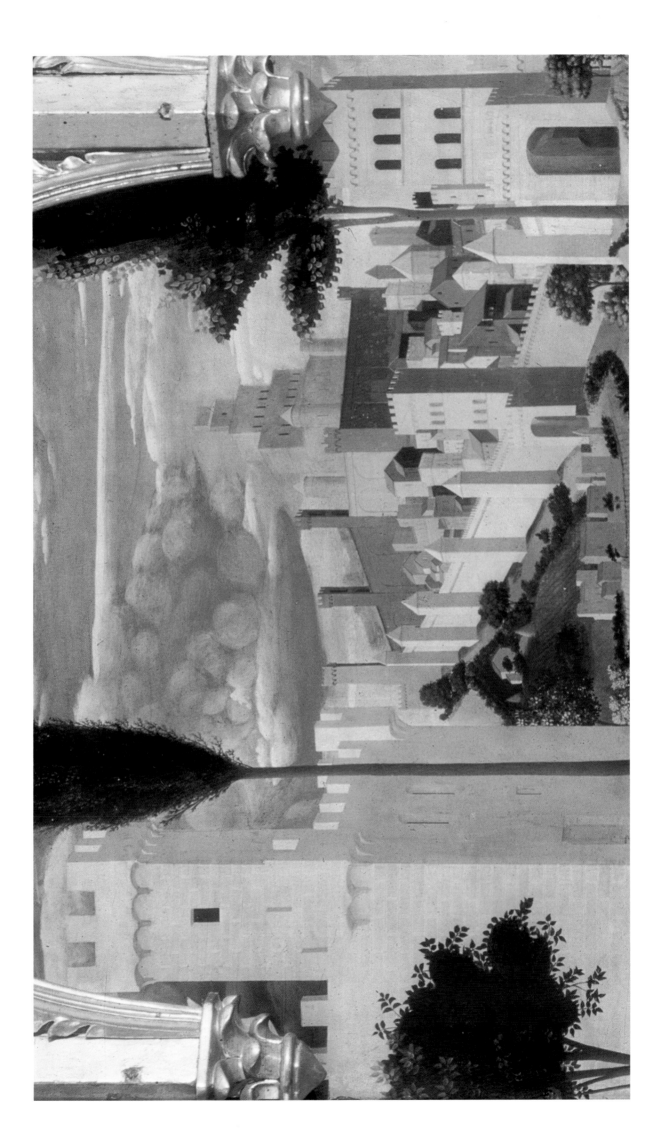

15 Detail from 'The Deposition from the Cross'
 (Plate 12)

In this further detail of Angelico's *Deposition* the towered buildings confirm the landscape as Italian. The hills stretch out into the distance, softened and smoothed by the light, peppered with gleaming villages and farmhouses. The foreground rocks are insufficiently distant to be mellowed, and are shown with all their facets and angularity. A row of trees again screens the landscape, emphasizing its distance. This is the forerunner of the bolder and more regular row of trees which strides across Angelico's *The Decapitation of St Cosmas and St Damian* (Plate 26). Having already pioneered the depiction of a genuine landscape scene in *The Visitation*, Angelico has here proved his ability not only to invent a landscape of exquisite beauty, but also to combine it with figures, in a harmonious union unrivalled by any of his contemporaries.

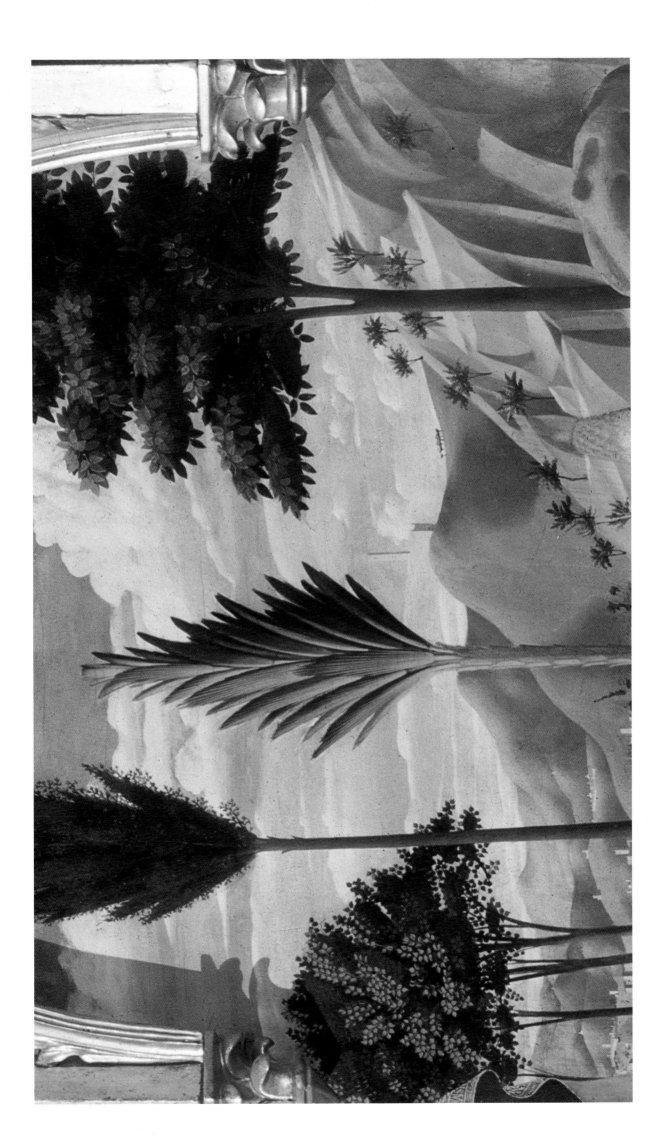

Detail from 'The Deposition from the Cross'
(Plate 12)

Angelico stops short of portraying the figures lamenting Christ's death in the agonies of grief; instead he shows them in langorous contemplation of their inner sorrow. Mary Magdalen kneels before Christ, taking his feet in her hands and kissing them. The Virgin kneels, her hands clasped, head on one side in reflective misery, with an air of particular detachment. She is partly screened from the viewer by the winding sheet held before her. The other holy women stand in positions of contemplation or prayer; one wipes a tear from her eye. As in earlier paintings by Angelico, the sense of the space in which the Virgin kneels is created by placing figures in a circle around her. In the background the road begins to wind its way up to Jerusalem.

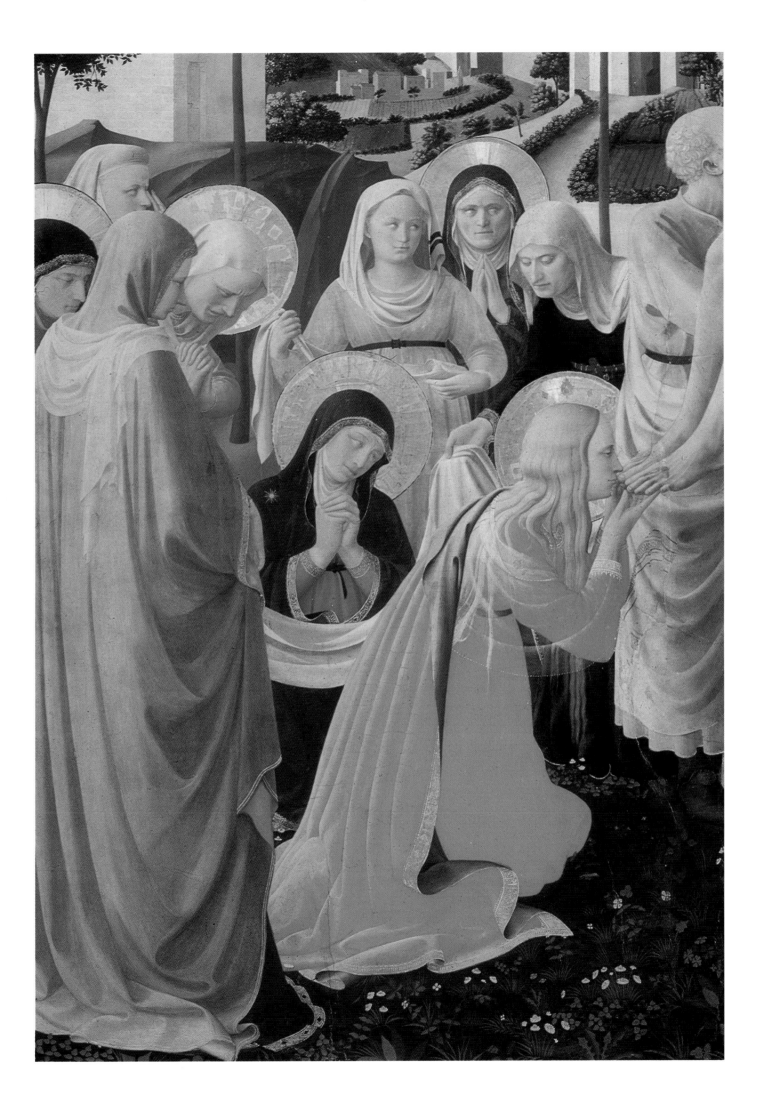

Detail from 'The Deposition from the Cross'
(Plate 12)

17

Kneeling in the foreground of the picture is a Beato. He echoes the Magdalen in his position, pose and red gown. A foreshortened arm extends out towards the viewer, drawing us into the scene before us. It has been suggested that this figure is Alessio degli Strozzi, the dead son of the family whose patronage brought about the creation of the work. Behind him are five men, standing further forward in the picture plane than the women on the other side whom they balance. Like the women each is contemplative, reticent and mournful. One displays to the others some of the instruments of crucifixion: three gruesomely large nails with heavy drips of blood on them, and the neatly woven circlet of thorns whose perforations can be seen on Christ's brow. Beneath their feet, indicative of Angelico's enjoyment of the portrayal of nature, is the richly leafed and flowered turf which is common to so many of his paintings.

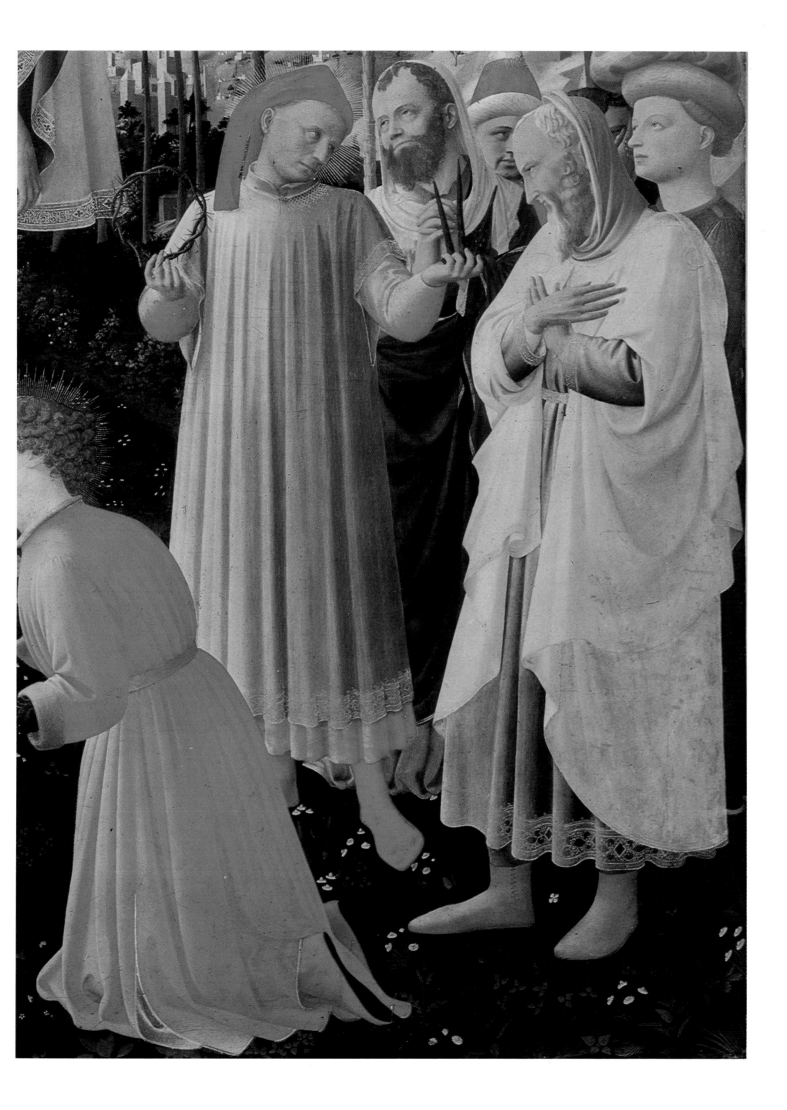

The Annunciation

1450. Fresco, 216 x 321 cm. San Marco (Upper corridor), Florence

At the top of the stairs on the upper corridor of the convent at San Marco, this fresco was painted on Angelico's return from Rome in 1450, and is therefore several years later than the majority of the frescoes at San Marco. In style it falls between the sparseness of *The Annunciation* in cell three and the richness of the Cortona altarpiece. Unlike in the Cortona version, the garden is here viewed through a colonnade of columns which recede to a vanishing point near the centre of the painting. The Virgin sits on a wooden stool and appears to have been roused from meditation rather than disturbed from reading, as she has no book. She is set back from the front of the loggia and she and Gabriel face each other along a diagonal. Beyond her in the next chamber can be seen a barred window, symbolic of her chastity and, like the high palisade which surrounds the garden, indicative of a secluded, contemplative life. The hues of the pallet may be closer to the work in cell three than those in the Cortona altarpiece, but the architectural detailing is richer than either. The sturdy columns with richly foliated corinthian capitals are akin to those in the Vatican fresco of *The Ordination of St Stephen*, although they are curiously combined here with ionic capitals of equal richness.

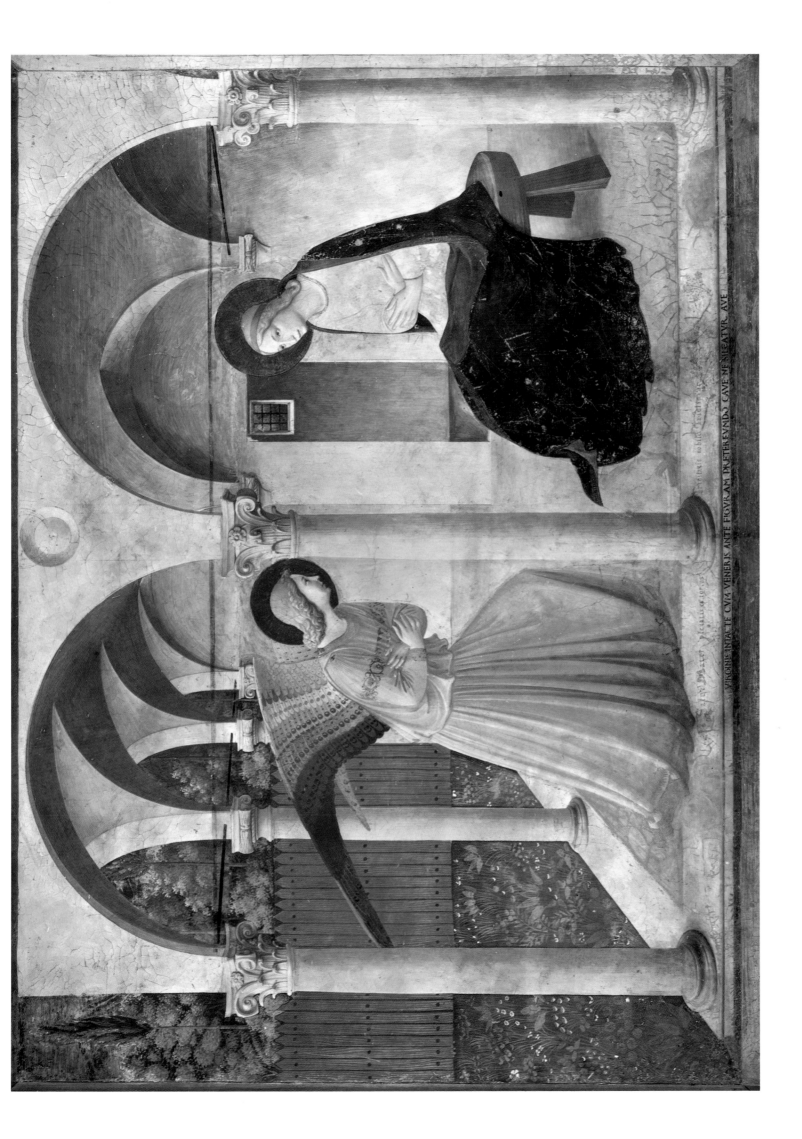

19 The Coronation of the Virgin

c.1441-3. Fresco, 189 x 159 cm. San Marco (Cell 9), Florence

In another scene of luminous albescence the Virgin is crowned by her Son. They and the accompanying Franciscan and Dominican saints sit on tiers of cloud of arctic whiteness. These six saints can be seen as a token representation of the elect, who surround Christ and the Virgin in heaven in the traditional rendering of this scene. But like so many other figures in the series of San Marco frescoes, they have an air of detachment from the events to which they are nominally witnesses. They hold their hands out in adoration and gaze heavenwards, but none looks directly at the scene of coronation. The Virgin, with her arms folded over her chest, leans forward to receive the crown. She is seated beside Christ, in accordance with the usual composition for this subject. Angelico was later to break away from this in his *Coronation of the Virgin* of c.1450 (Plate 39), now in the Louvre, which shows Mary kneeling before Christ. In this series of frescoes at San Marco Angelico has not turned back to medieval prototypes but instead, through economy in the use of figures, restraint in the overt expression of emotion, and austere use of colour, he has created his own meditative images of remarkable force.

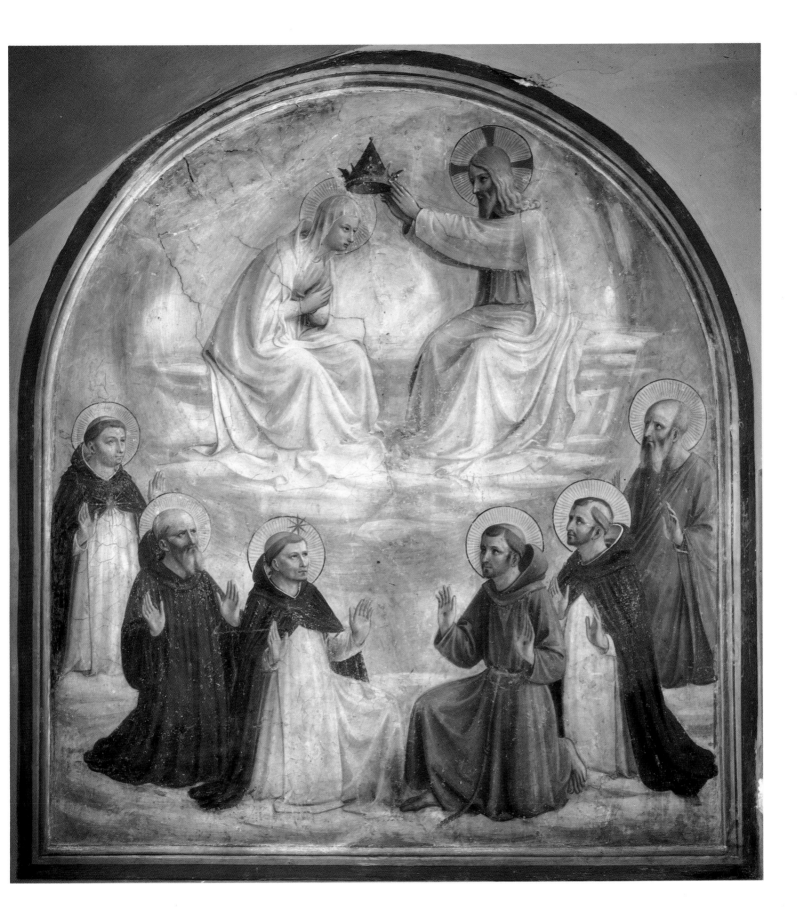

The Virgin and Child Enthroned with Four Angels

1437. Centre panel of an altarpiece. Panel, 130 x 77 cm. Galleria Nazionale dell'Umbria, Perugia

Fig. 21
St Nicholas addressing an Imperial Emissary, and saving a Ship at Sea

1437. A predella panel of the Perugia altarpiece. Pinacoteca Vaticana, Rome

This panel was at the centre of a polyptych painted for the St Nicholas chapel in the church of San Domenico at Perugia. The Virgin and Child are shown enthroned between St Dominic and St Nicholas of Bari (Plate 22) and St John the Baptist and St Catherine of Alexandria (Plate 23). The work is now displayed without its original frame, and the area which this covered can easily be seen along the upper edge of the panel. Compared with the Linaiuoli altarpiece (Plate 11), this Virgin is less monumental and the Child altogether more sinuous and fleshy. Angelico returns to the circle of angels to create an additional sense of depth, but here the two who would have stood forward of the throne have been replaced by three vases of flowers. The Virgin's throne is a solid classical affair with round arch and pilasters, topped with a swagged frieze, in contrast to the pointed arch frame of the picture which would have hemmed it in at the top. The background of the panel is still gold and abstract.

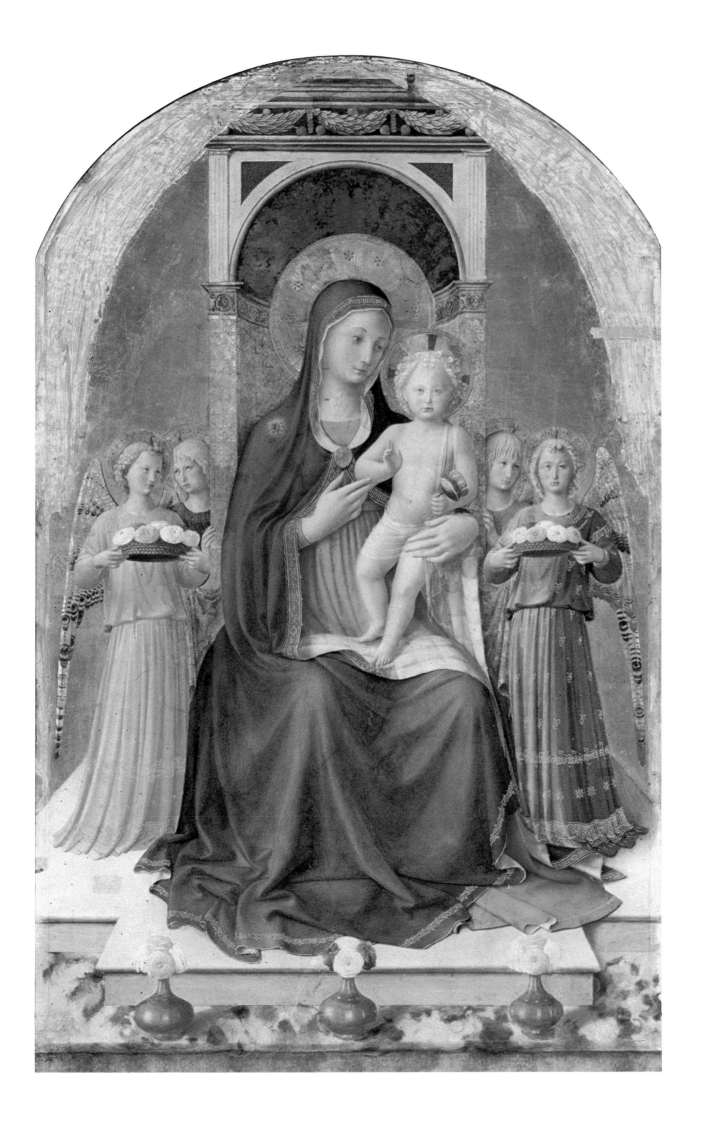

21 The Virgin and Child Enthroned
with Four Angels

c.1435. Centre panel of an altarpiece. Panel, 137 x 68 cm. Museo Diocesano, Cortona

Angelico painted an altarpiece for San Domenico at Cortona a year or two before the Perugia altarpiece (Plate 20). It formed a polyptych with pointed Gothic frames to its panels; the centre panel is shown here. Both this *Virgin and Child* panel and that at Perugia follow the same formula, but this has a more self-contained, meditative feel about it, as none of the figures regards the viewer and the Virgin looks not at her Son, but into the middle distance with contemplative gaze. This mood is closer to Angelico's series of frescoes in the cells at the convent of San Marco, in Florence.

Restoration of this altarpiece in the 1940s necessitated the removal of the layers of paint from the wooden panels. On the back of each paint membrane was a fine underdrawing. All in the same hand, presumably Angelico's, the details of line are delicately rendered and the emphasis of the composition at this stage is essentially linear, showing few of the qualities of depth and recession which appear in the completed work. In the final state much of the underlying linear fineness is sacrificed, to secure a greater solidity.

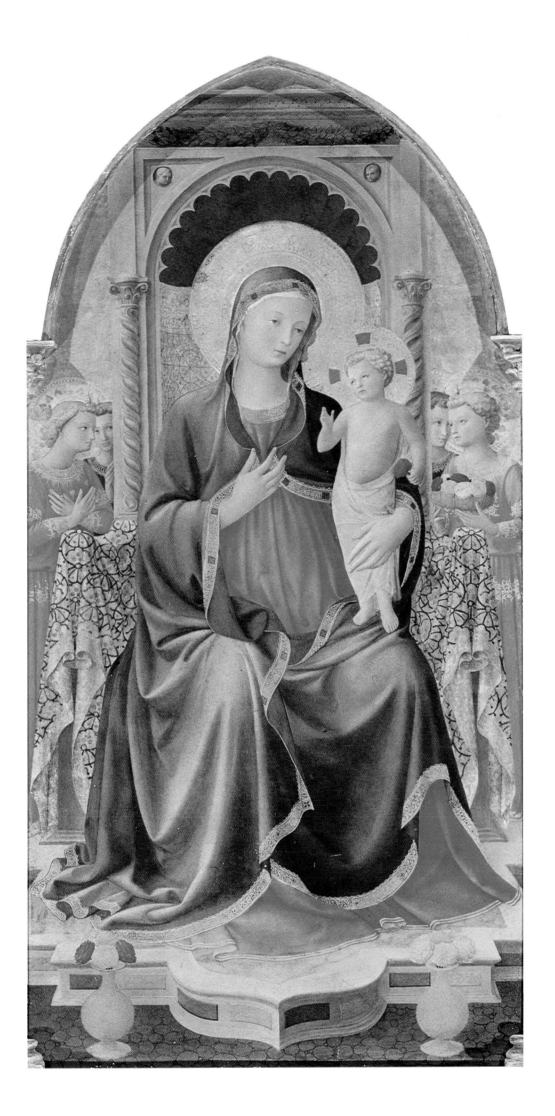

1437. Side panel from the Perugia altarpiece (Plate 20). Panel, 95 x 73 cm. Galleria Nazionale dell'Umbria, Perugia

Fig. 22
The Birth and
the Vocation
of St Nicholas and
St Nicholas and the
Three Maidens

1437. A predella panel of
the Perugia altarpiece.
Pinacoteca Vaticana,
Rome

St Dominic and St Nicholas of Bari stand to the Virgin's right. They lack the sculptural monumentality of the saints in the Linaiuoli altarpiece, are lit in a softer and more diffuse manner, and are not made to stand in a darkened niche. Here, for the first time Angelico breaks away from the convention of the abstract, all-surrounding gold, and places the figures in front of a long table, whose end can be seen behind St Nicholas of Bari who has placed his mitre on it. This is not, however, so great a departure from convention as might be implied, as the table is covered with a golden cloth and beyond it is the usual gold background. The two figures stand at the very front of the space created, St Dominic's foot and St Nicholas's vestments touching the edge of the step. St Nicholas wears his bishop's cope and supports his crook, while at his feet are three full leather bags. These refer to the most popular legend concerning this fourth-century churchman. He reputedly tossed bags of gold through the open window of a house, providing the three women who lived within with dowries and thus saving them from turning to prostitution. The event is shown, with two other scenes from the saint's life, in one of the predella panels from the altarpiece (Fig. 22).

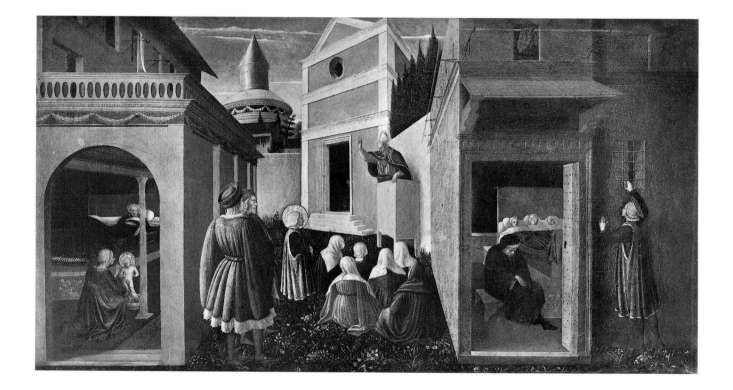

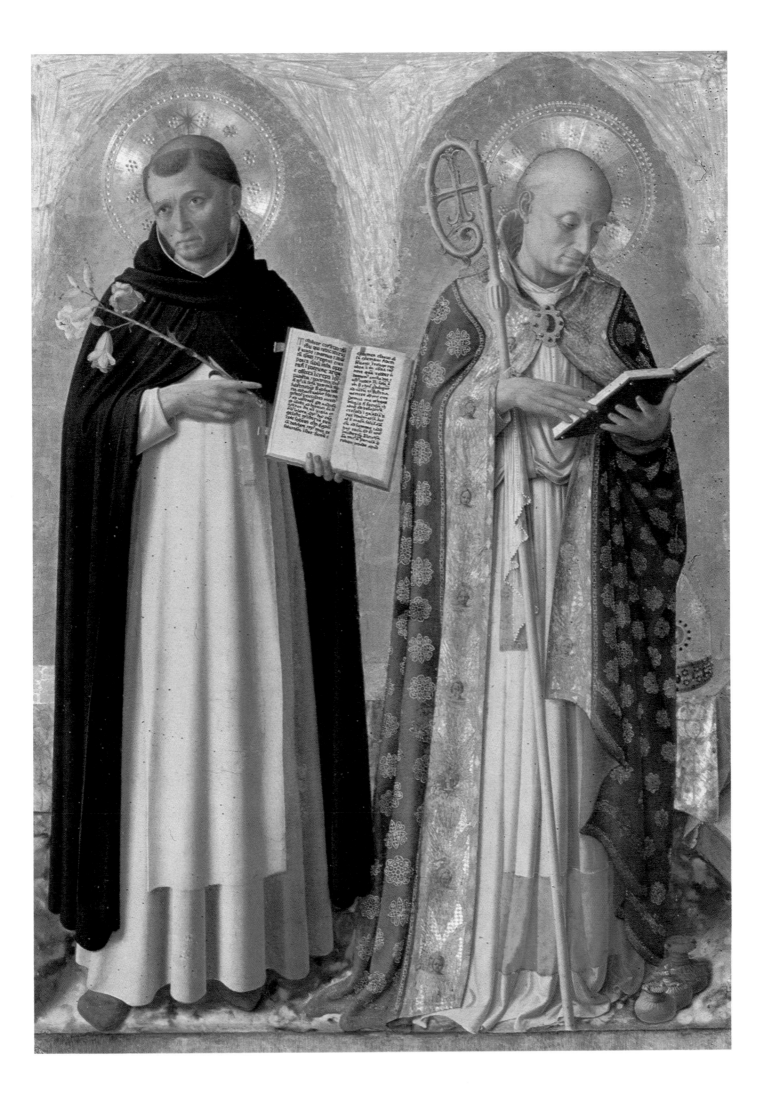

St John the Baptist and
St Catherine of Alexandria

1437. Side panel from the Perugia altarpiece (Plate 20). Panel, 95 x 73 cm. Galleria Nazionale dell'Umbria, Perugia

St John the Baptist and St Catherine of Alexandria stand at the edge of the step and, like their companion saints in the altarpiece, have a table running behind them. St John's cross is tucked nonchalantly behind his halo and the base of it sticks right forward, but neither this nor his foreshortened hand recreate the impression of three-dimensionality with which he was rendered in the Linaiuoli altarpiece. He holds a scroll with a quotation from his own words, 'Behold the Lamb of God, which taketh away the sin of the world', (John 1, v. 29). Pope-Hennessy sees the hand of assistants, rather than primarily that of the master, in these two figures. St Catherine has fewer sculptural qualities still. Beside her is a broken wheel from the diabolical machine on which she was tested.

Another predella panel to this altarpiece shows St Nicholas saving three men from execution and the scene of his own death. The now familiar strongly lit, chunky architecture, screen of trees and light-softened Tuscan landscape appear on the left, while on the right the starkness of a lightly articulated wall forces attention on the dying saint. Both scenes are given a remarkable cohesion by being lit from the same source.

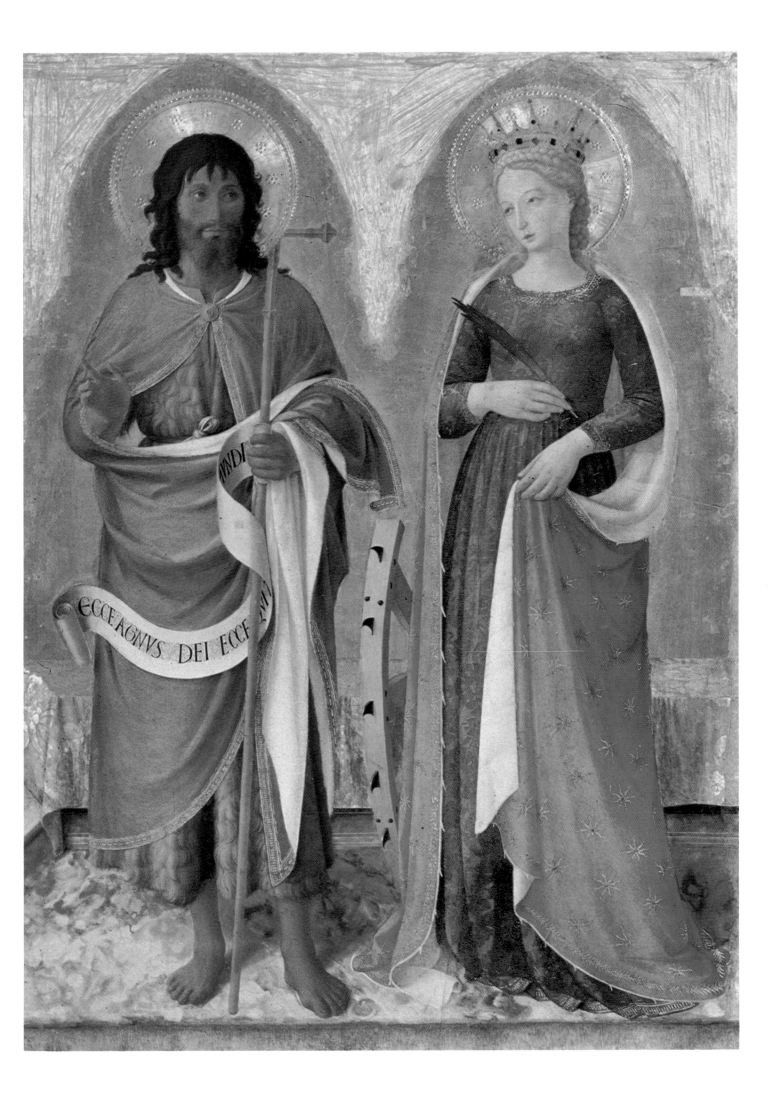

24

**The San Marco Altarpiece:
The Virgin and Child Enthroned with Angels
and Sts Cosmas and Damian, Lawrence, John
the Evangelist, Mark, Dominic, Francis and
Peter Martyr**

c.1440. Panel, 220 x 227 cm. Museo di San Marco, Florence

This altarpiece, commissioned for the San Marco convent by Cosimo de' Medici, is a work rich in innovation. The throne of the Virgin is removed from its usual gold surround and placed in a garden, before a backdrop of cypresses and palm trees. Joining her in the same scene are not only the usual angels but also an assortment of saints who previously would have been confined to their own panels. All the figures are together, and aware of each other, in the same space, forming one of the first examples of the *sacra conversazione*. There is greater spatial depth here than in any previous altarpiece, largely as a result of the expanse of geometric carpet whose converging orthogonals combine with those of the cornice of the towering throne to powerful effect. The whole is framed by looped gold curtains and two swags of pink and white roses. The throne is indebted in its style to the work of Michelozzo, who was then building at the convent. St Mark holds his own Gospel open at the passage which describes Christ's teaching in the synagogue, and includes his injunction to the Apostles to follow a life of poverty. St Cosmas kneels, looking out at the viewer (Fig.23). His face expresses peculiarly marked grief and suffering for a figure by Angelico's hand.

Fig. 23
Detail from
Plate 24

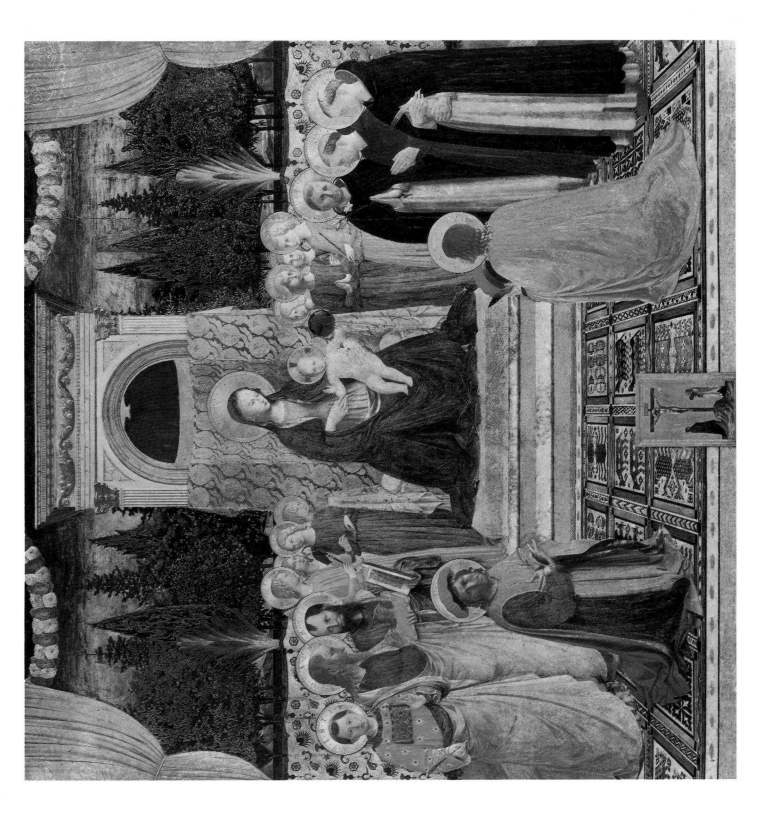

The Entombment

c.1440. Panel from the predella of the San Marco altarpiece (Plate 24). Panel, 38 x 46 cm.
Alte Pinakothek, Munich

The centre predella panel of the San Marco altarpiece is not overtly connected to the scenes on either side of it, which show the life of Sts Cosmas and Damian, although it too is lit from the right. Instead it relates directly to the crucifixion at the base of the altarpiece which, when the predella was in situ, was immediately above it. Christ's body is supported by Nicodemus, and his hands are held and kissed by the stooping Virgin and St John. Christ has a weightless air about him, so that the three other figures appear to have to do little to support him. The winding cloth lies stretched out in a receding rectangle creating the foreground space, its folds and colour echoing the white rock. Behind lies the dark rectangular void of the tomb. The sparsity and simplicity of the composition, the firmly closed-off space and the extensive use of white in this panel, are all also found in Angelico's frescoes at San Marco.

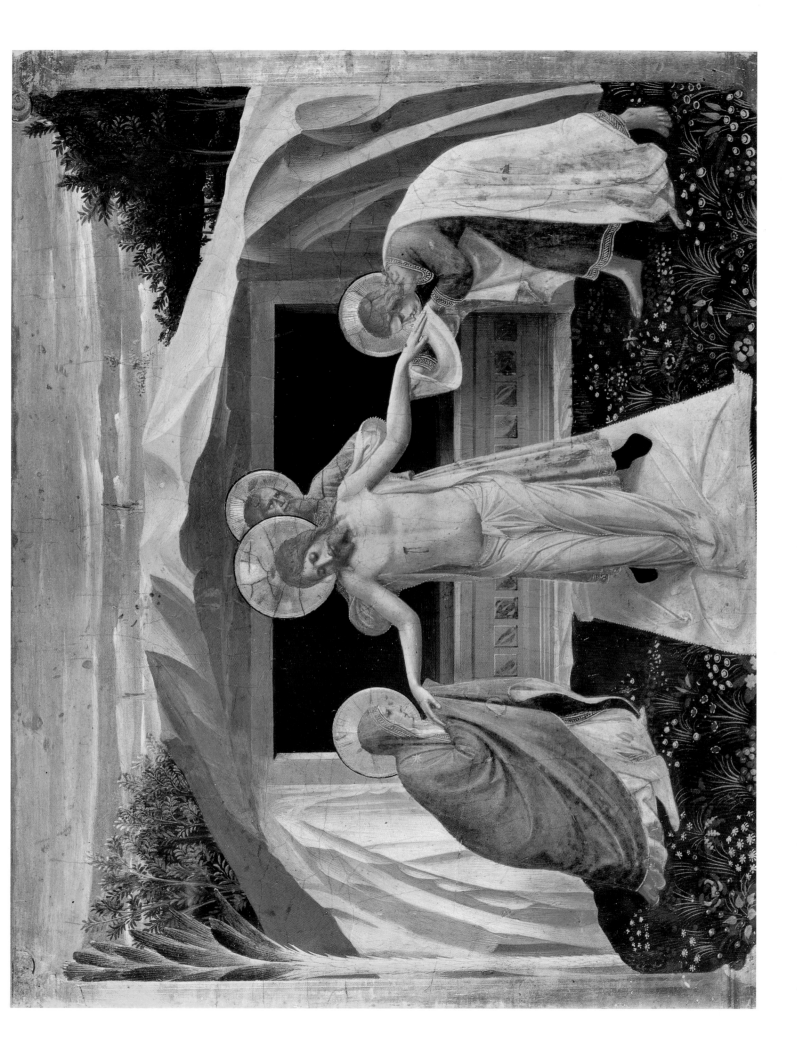

The Decapitation of St Cosmas and St Damian

c.1440. Panel from the predella of the San Marco altarpiece (Plate 24). Panel, 36 x 46 cm. Louvre, Paris

The legend of Sts Cosmas and Damian, twin brothers who were famed for making no charges for their services as physicians, is outlined in the predella panels of this San Marco altarpiece. Several attempts to put them to death failed, until the last, pictured here. The final moments of the two brothers are shown set against one of Angelico's finest landscapes. Outside a town with fortifications akin to those of Jerusalem in his *Deposition*, the two saints wait to join the three headless figures in the foreground. The greatest emphasis falls on the one who kneels directly in front of a row of five cypresses which runs parallel to the picture plane. These are a more formal version of the screens of trees in *The Deposition* (Plate 12), which marked the middle distance and helped unify the landscape with the foreground. Here they can also be taken to symbolize the five being executed.

In *The Attempted Martyrdom of Sts Cosmas and Damian by Fire* (Fig. 31) the drama is played out before a large blank wall which fulfils the same role as the row of trees in *The Decapitation*, and the dark rectangle behind Christ in *The Entombment* (Plate 25).

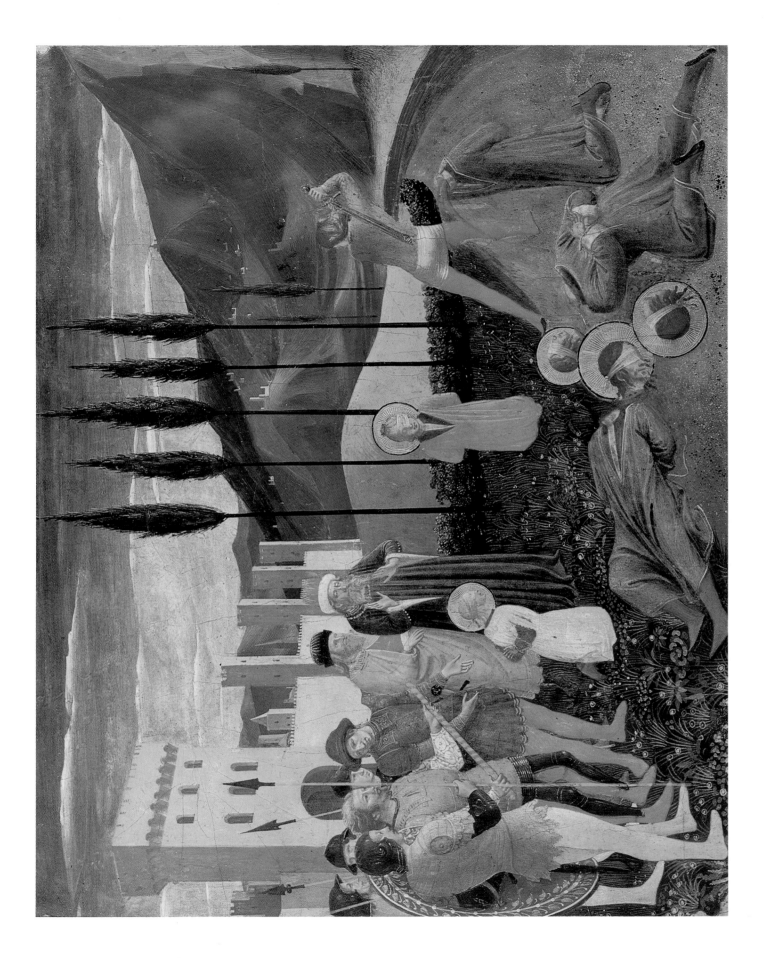

The Dream of the Deacon Justinian

c.1440. Panel from the predella of the San Marco altarpiece (Plate 24). Panel, 37 x 45 cm. Museo di San Marco, Florence

Justinian sleeps while Sts Cosmas and Damian enter his chamber trailing patches of soft cloud. They replace his corrupted leg with a healthy one. The room is spartan but the variety of light-sources and Angelico's close observation give it interest. Light floods in from outside through the window on the left, illuminating its own frame and parts of the swags of curtain. Exterior space is indicated not only by the window but by the door opposite it, from whence comes more light. From the front left outside the picture comes the third source of light, which produces a broad diagonal sweep across the right wall. The curtain provides the rectangular backdrop parallel to the picture surface which is common to each of these predella panels, and also hints at more, obscured space behind it. The container hanging from a nail on the side of the bed, the glass and decanter, the slippers and the simple three-legged stool, all provide the constituents of a closely observed still-life.

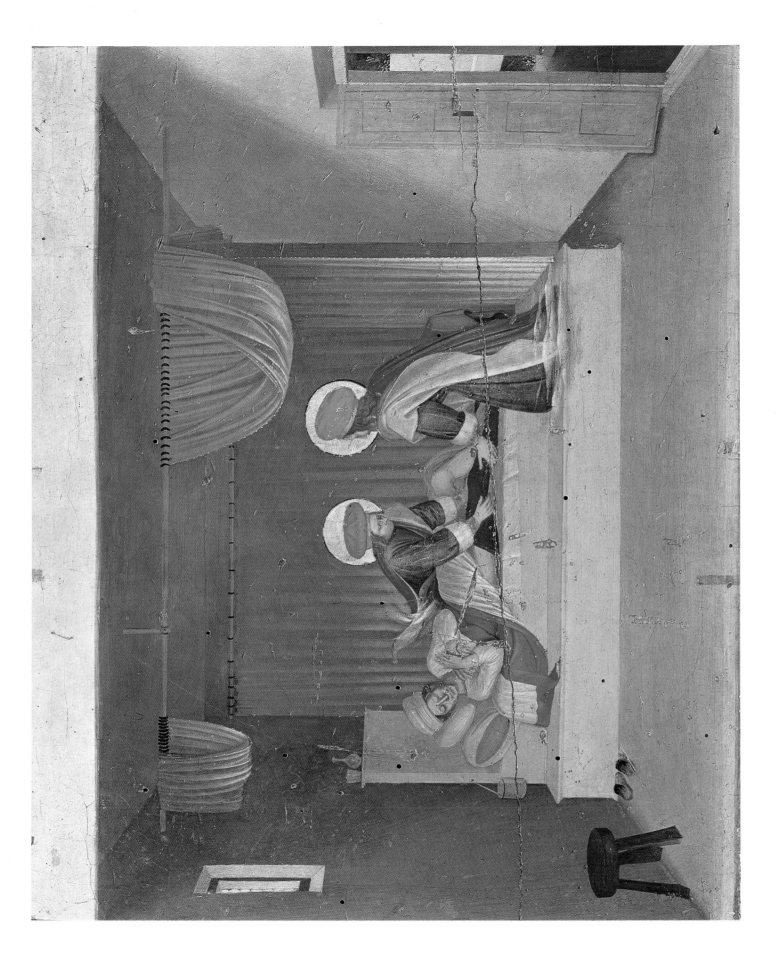

28 The Annunciation

c.1441-3. Fresco, 187 x 157 cm. San Marco (Cell 3), Florence

The return of Cosimo de' Medici to Florence in 1434 enabled the Dominicans, of whom he had long been a patron, to secure for themselves the ruined convent of San Marco. Its rebuilding began in 1437, and its decoration very soon after. Comparison between this *Annunciation* and the Cortona *Annunciation* shows very clearly how the style Angelico adopted for this cycle of frescoes differed from that employed in the rest of his work. The San Marco frescoes were intended not as means of instruction, still less as decoration, but as aids to contemplation and meditation. The brother who inhabited each cell was to have constantly before his eyes a vivid yet chaste reminder of one of the events in the life of Christ.

The composition of this fresco is severe in the extreme. The Virgin inhabits not a house but a cell as spartan as that in which the fresco is painted, and beyond Gabriel and Mary the eye meets only a plain blank wall. The one piece of decoration, the capital of the column, is deliberately obscured by the wing of the angel. Here and throughout the series the pallet is extremely restrained, as if Angelico thought rich and varied colours were as likely as decoration to distract the friars from spiritual contemplation.

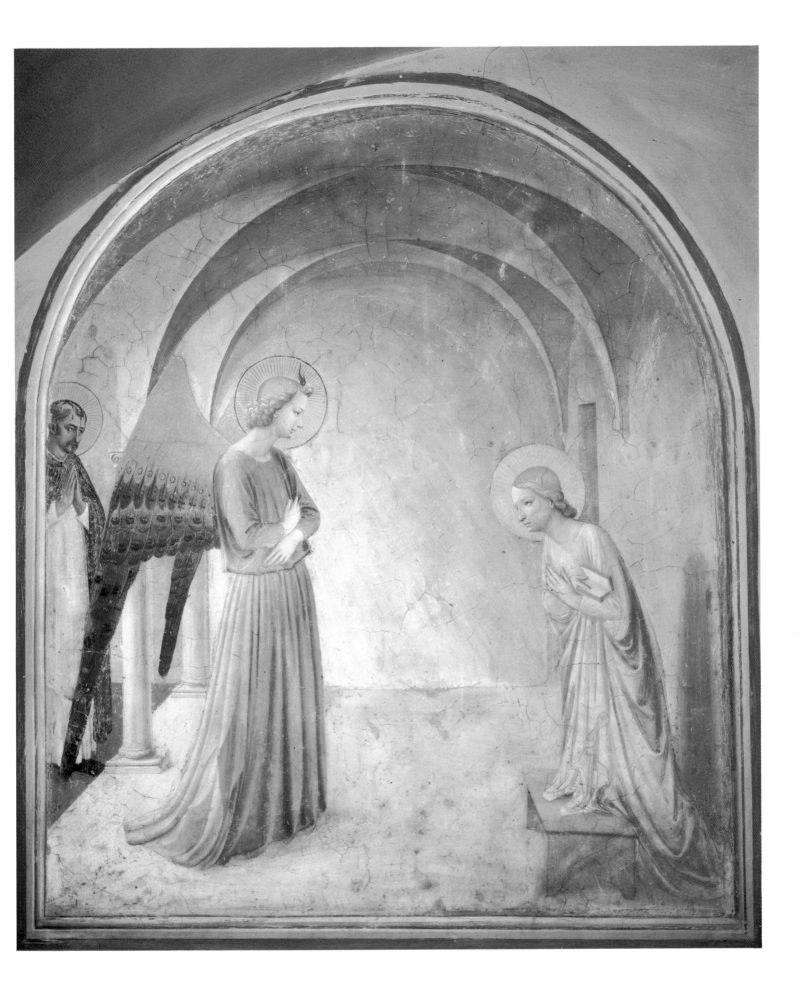

Noli Me Tangere

c.1441-3. Fresco, 177 x 139 cm. San Marco (Cell 1), Florence

Fig. 24
Detail from
Plate 29

This scene is not as chaste as the foregoing *Annunciation* – Angelico indulges his predilection for the painting of nature in the form of trees and a meadow – but the essential composition is similar and as restrained. The two figures incline demurely towards each other, and although there is no blank wall behind them the eye does run up against the broad palisade fence that encloses the garden. The dark, empty doorway of the tomb provides a focus on the left of the picture, just as the figure of St Peter Martyr does in *The Annunciation*. The moment depicted is that described in the Gospel of St John where Christ appears at the sepulchre to Mary Magdalen, who at first thinks he is a gardener. She then recognizes Him and He instructs her to 'Touch me not; for I am not yet ascended to my Father' (John 20, v. 17), from which first phrase depictions of this scene take their name. Christ is given an ethereal appearance, seeming to float across the grass, his legs crossed right over each other. The stigmata show clearly.

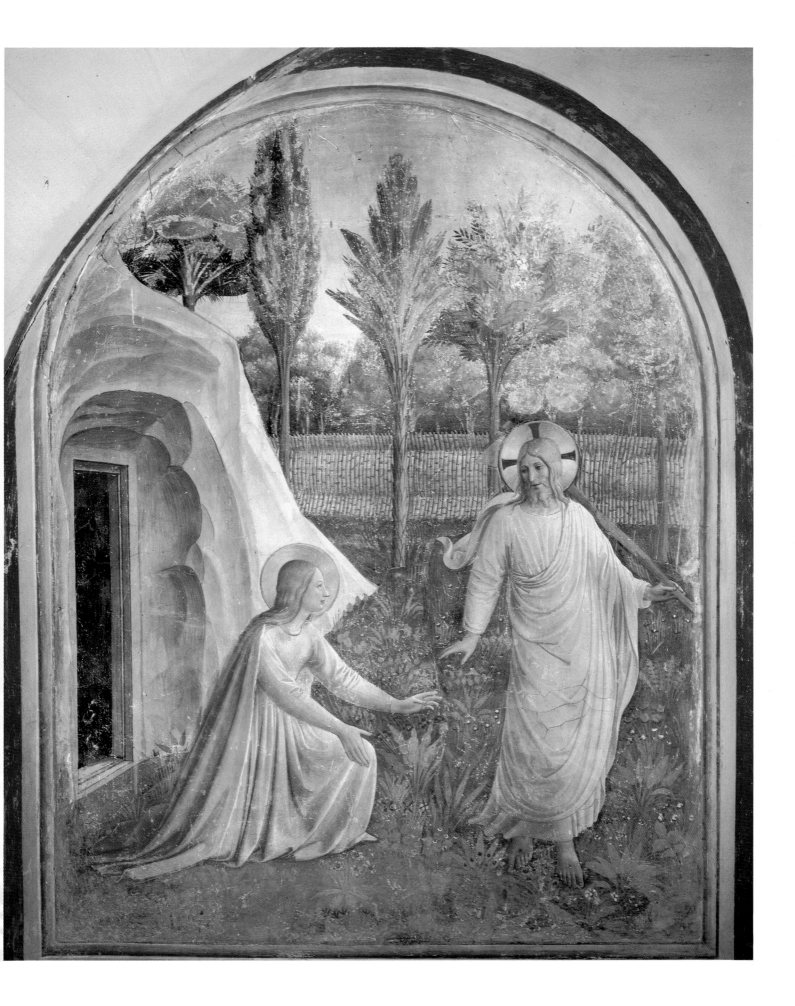

The Mocking of Christ

c.1441-3. Fresco, 195 x 159 cm. San Marco (Cell 7), Florence

The contemplative restraint of the San Marco frescoes is nowhere better illustrated than in *The Mocking of Christ*. Rather than paint Christ's humiliations in their full violence in a complex narrative work, they are reduced to a series of iconographic symbols. In doing this Angelico was drawing on established trecento precedents. In a plain-walled room Christ sits on a dais in a luminous white robe and tunic. The great slab of white marble beneath Him adds to the air of radiant whiteness surrounding Him. He is blindfolded, with a crown of thorns about his head. Behind Him hanging from a plain frieze is a screen on which are painted the emblems of his indignities: the head of the spitting soldier, the hands of the buffeters, the hand and stick forcing the thorns down on his head. On a low step at the front of the picture sit the Virgin and St Dominic. Neither regard Christ but sit with their backs turned towards him in poses of intense meditation – the depth of meditation that the frescoes were designed to assist each friar to attain.

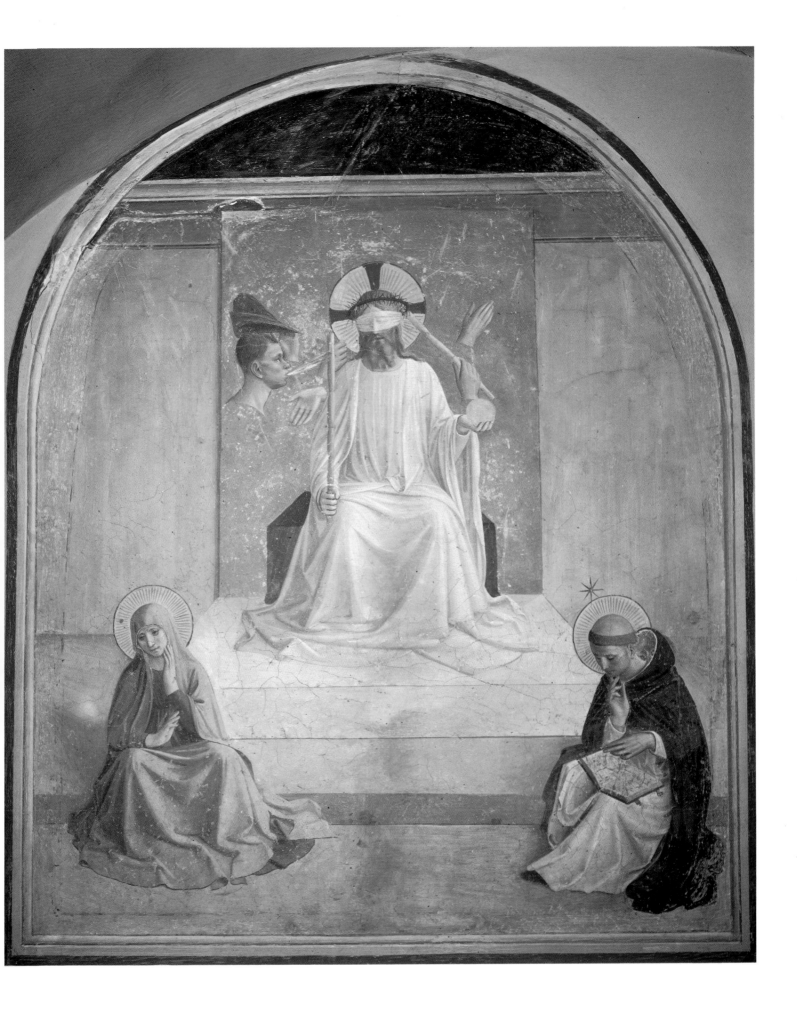

The Transfiguration

c.1441-3. Fresco, 189 x 159 cm. San Marco (Cell 6), Florence

Fig. 25
Detail from
Plate 31

In this fresco Christ stands on a rock, prefiguring his rising from the tomb. His arms are outstretched and in this He also foreshadows his own crucifixion. He is voluminously clad in a sculptural mass of glowing white robe, and encircling Him is a radiant white mandorla. His forward gaze does not directly engage the eye of the spectator. At the base of the rock three of the Apostles crouch in awed positions, but they maintain the curious contemplative detachment from the drama of the scene which is the hallmark of this fresco cycle. At the edge of the fresco, on either side, stand the Virgin and St Dominic in positions indicative of prayer, stern and unresponsive to events around them. The heads of Moses and Elias appear beneath the arms of Christ; they are introduced as detached symbols to aid meditation. There is no attempt to create any more than the bare essentials of picture space; this particular spur to devotion required no more. For Angelico, too elaborate a spatial framework as much as excessive use of colour, decoration, or narrative, could detract from the picture's power.

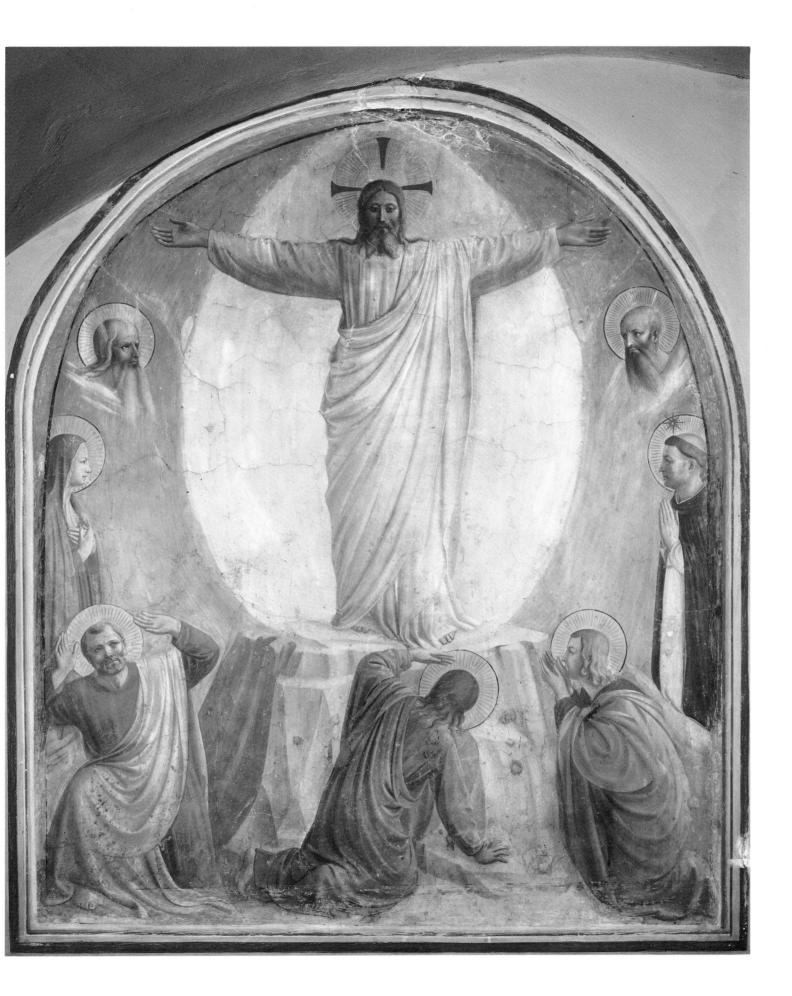

The Annalena Altarpiece:
The Virgin and Child Enthroned
with Sts Peter Martyr, Cosmas and Damian,
John the Evangelist, Lawrence, and Francis

c.1445. Panel, 180 x 202 cm. Museo di San Marco, Florence

Fig. 26
**Virgin and Child
Enthroned with
Eight Saints**

c.1450. San Marco, Upper
Corridor, Florence

This is Angelico's second *sacra conversazione*, and shares many elements in common with its forerunner, the San Marco altarpiece. Unlike the San Marco altarpiece, however, there are no angels here and the Virgin and Child are in the company only of Sts Peter Martyr, Cosmas, Damian, John the Evangelist, Lawrence and Francis. Although they have left their individual panels, never to return, there is still an echo of these in the blank arches of the wall which closes the back of the picture. The high wall and its pink cornice run the full width of the panel. The natural world, which was the setting of the first altarpiece, is now confined to the grass and flowers at the very front of the picture. There is no carpet on the ground here and the foreground is much shallower than in the earlier work. The method of space projection remains basically the same and relies on the receding rectangles of the steps to the throne and of its cornice. An element common to both altarpieces is the use of a carpet running across the back of the picture parallel to the picture plane.

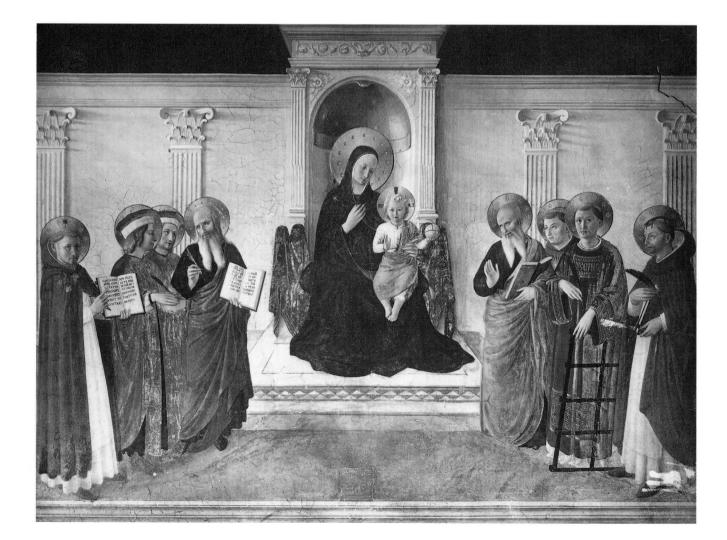

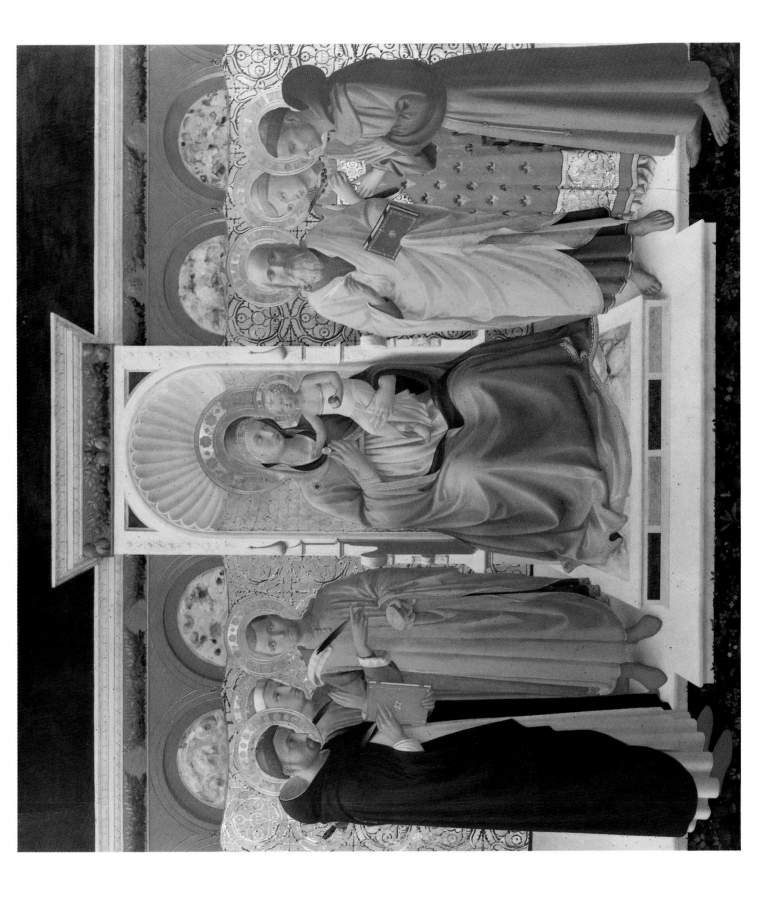

St Stephen preaching and St Stephen addressing the Council

c.1447-8. Fresco, 322 x 412 cm. Chapel of Pope Nicholas V, Vatican

It was the conscious policy of Pope Nicholas V, himself a scholar and man of letters, to ally the Church with the energy and artistic and intellectual ambitions of the Renaissance, and to set the papacy at the head of civilization. He was responsible for the rebuilding and decoration of numerous palaces and churches, and Angelico's fresco series in the Vatican was an important contribution to this work. The paintings are markedly different in emphasis from those of San Marco. The purpose of these Roman frescoes was narrative, and to assist in the telling of his story Angelico used a richness of detail, multiformity of incident, number of figures and wealth of colour which has no parallel in the earlier work. The lunette shown here contains two scenes from the life of St Stephen. On the left he preaches to an array of figures placed throughout the vista of space. To the right, in a chamber which is also embedded in the lefthand scene yet has a different perspective framework, St Stephen addresses the council. Here the depth of the picture is truncated by a blank wall hung with a curtain.

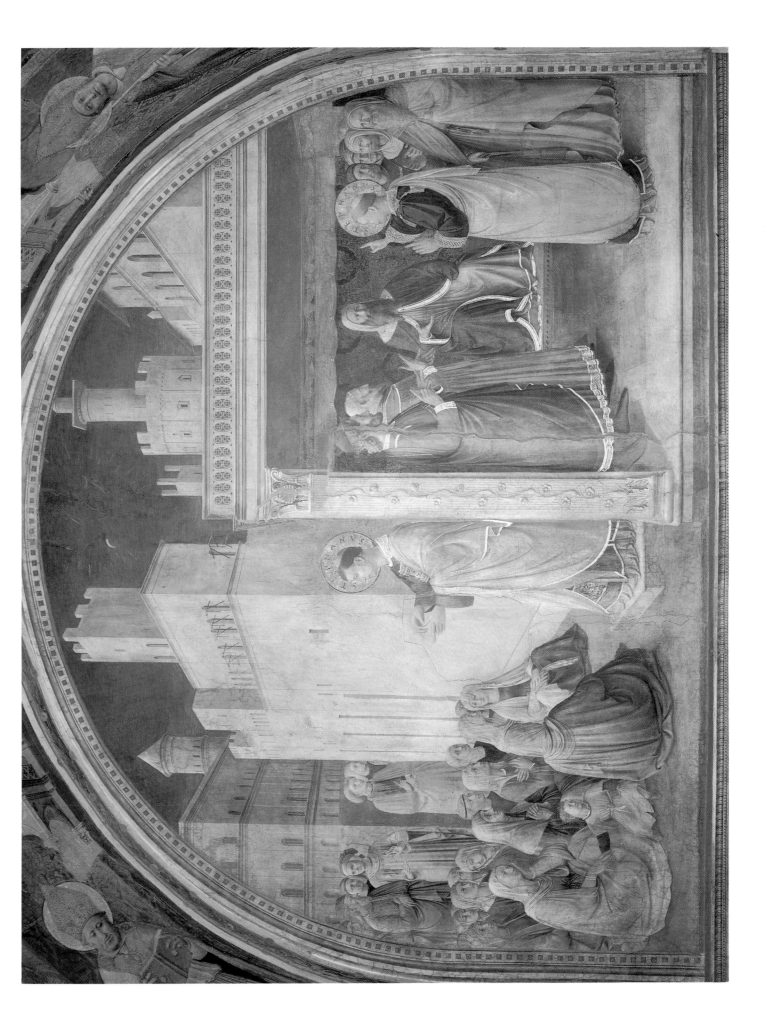

34

St Lawrence receiving the Treasures of the Church and St Lawrence distributing Alms

c.1447-8. Fresco, 271 x 473 cm. Chapel of Pope Nicholas V, Vatican

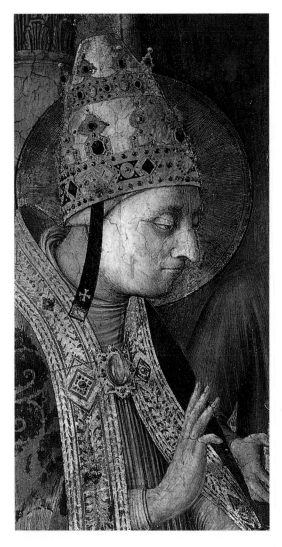

Fig. 27
Detail from
Plate 34

St Lawrence, a third-century Roman who, like St Stephen, suffered a violent death for his faith, was venerated as one of the most famous martyrs of the city of Rome. This fresco panel is divided in two, without any attempt to give the neighbouring scenes any architectural or spatial cohesion. The architecture employed by Angelico in both scenes is of a distinctly Roman splendour and dignity. The two events from the life of the saint are simply told . They are rich in detail but none is superfluous to the narrative. On the left he kneels to receive the treasures of the Church from Pope St Sixtus II, who is given the features of Angelico's patron, Nicholas V (Fig. 10). It has been suggested that the depiction of the two soldiers preparing to break open a bricked-up door, is a reference to Pope Nicholas's decision to declare 1450 a Jubilee Year. On the right, St Lawrence is shown framed in the entrance to a colonnaded basilica of great monumentality. The distant apse further frames and gives emphasis to the saint. He is attended by the poor, blind and lame, and hands money to a legless man in the immediate foreground. His scarlet vestment is scattered with golden flames and hints at his future death by burning.

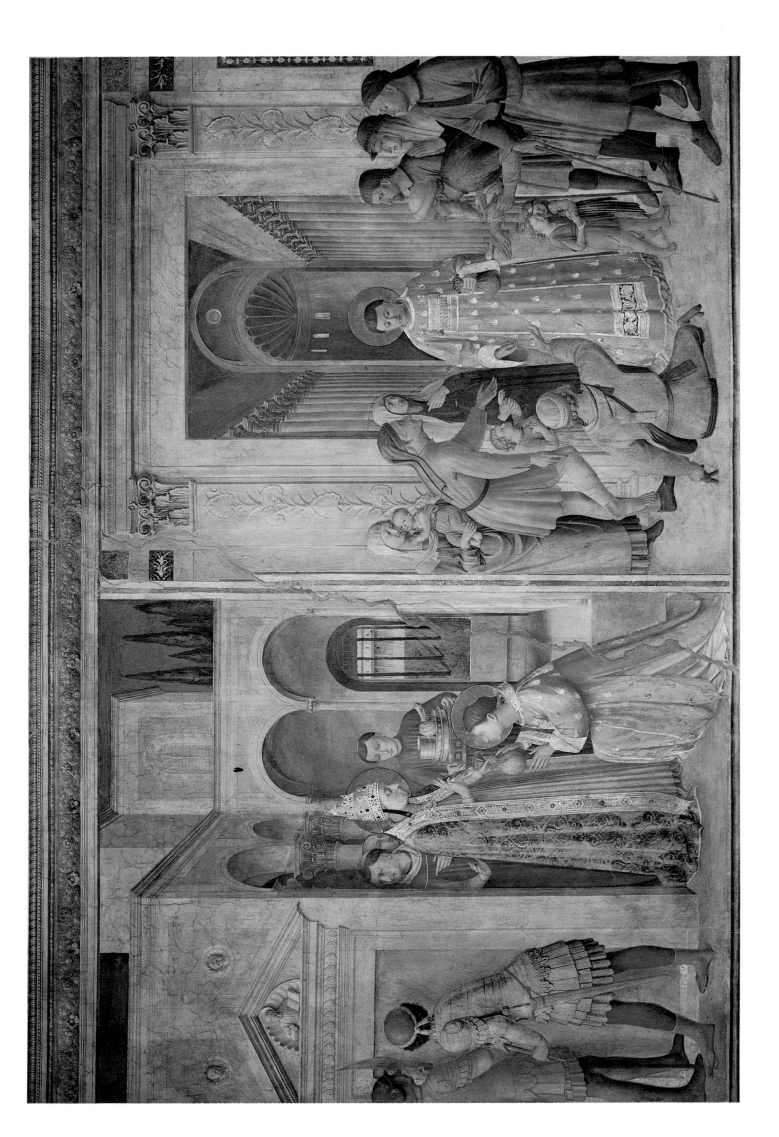

St Lawrence before Valerianus
(left half of St Lawrence before Valerianus and The Martyrdom of St Lawrence)

c.1447-8. Fresco, 271 x 473 cm. Chapel of Pope Nicholas V, Vatican

Fig. 28
St Lawrence
before Valerianus;
the Martyrdom of
St Lawrence

c.1447-8. Chapel of Pope
Nicholas V, Vatican

This scene is part of a larger fresco which includes a depiction of St Lawrence's martyrdom. The two are linked by the cornice which, although it changes in its detailing, is essentially common to both scenes. The composition of *St Lawrence before Valerianus* owes much to Angelico's earlier *sacra conversazione*. The wall broken into sections by pilasters, hung with a rich ornamental curtain and incorporating a lofty architectural throne, is familiar from the Annalena altarpiece of a couple of years before (Plate 32). The tops of trees protruding from behind the wall prefigure those which appear in the same position in the Bosco ai Frati altarpiece (Plate 38). Various soldiers and city worthies stand in a circle before the Emperor, helping to create a sense of depth without the assistance of any converging orthogonals in the foreground. In the centre of the fresco is a third scene, the conversion of Hippolytus, St Lawrence's gaoler. On the far right of the panel St Lawrence is held down on his gridiron and is engulfed by flames: a brutal act, committed against the backdrop of a wall parallel to the surface of the picture and watched from on high by its perpetrator. Angelico uses this combination of elements again in *The Attempted Martyrdom of Sts Cosmas and Damian by Fire* (Fig. 31) and *The Massacre of the Innocents* (Plate 43).

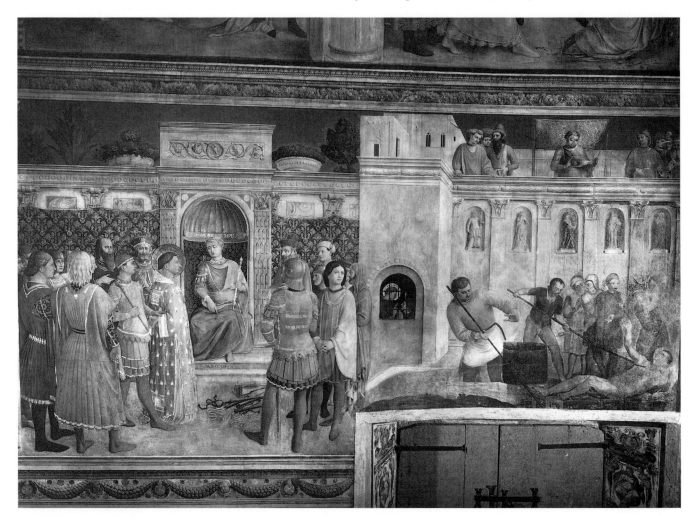

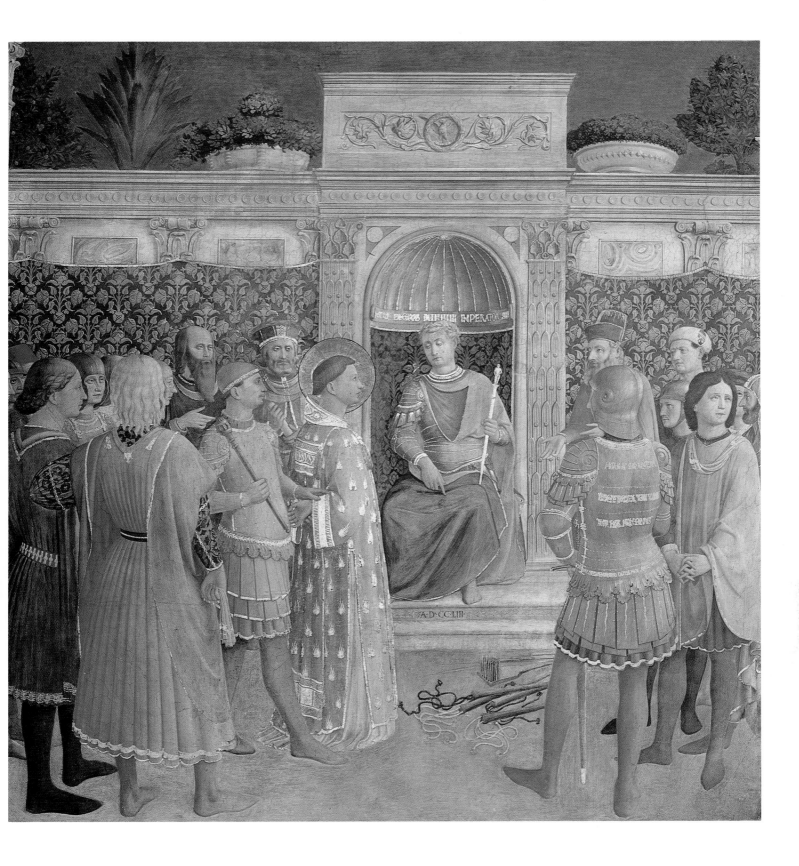

The Stoning of St Stephen
(right half of The Expulsion of St Stephen and The Stoning of St Stephen)

c.1447-8. Fresco, 322 x 236 cm. Chapel of Pope Nicholas V, Vatican

Fig. 29
The Expulsion
of St Stephen;
the Stoning
of St Stephen

c.1447-8. Chapel of Pope
Nicholas V, Vatican

This lunette is divided in two by the monumental city wall which forms a natural part of both the scenes portrayed. The architecture recalls the city walls in *The Deposition* (Plate 12), although it shows certain refinements of detail absent in the earlier painting. The soft hills strewn with collections of towers and houses are in Angelico's familiar landscape style. All lit from the same source, the lunette has a complete spatial unity. St Stephen, having incurred the wrath of the council, is dragged to the city gate and meets his fate outside it as the first Christian martyr. On the right he is portrayed at prayer following the description that 'he kneeled down, and cried with a loud voice, Lord, lay not this sin to their charge.' (Apostles 8, v. 60). Around him are the stones which have bloodied his face; two more bounce off the back of his head; one of his executioners raises another one high, about to strike again, and holds more in his robe. Saul, who was a consenting witness to the execution, is shown, following the details given in the Acts of the Apostles, as a young man holding part of Stephen's clothes which had been laid at his feet by the witnesses.

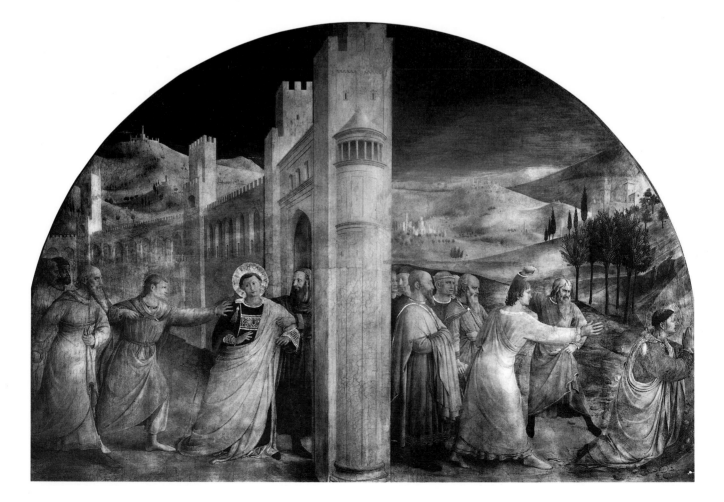

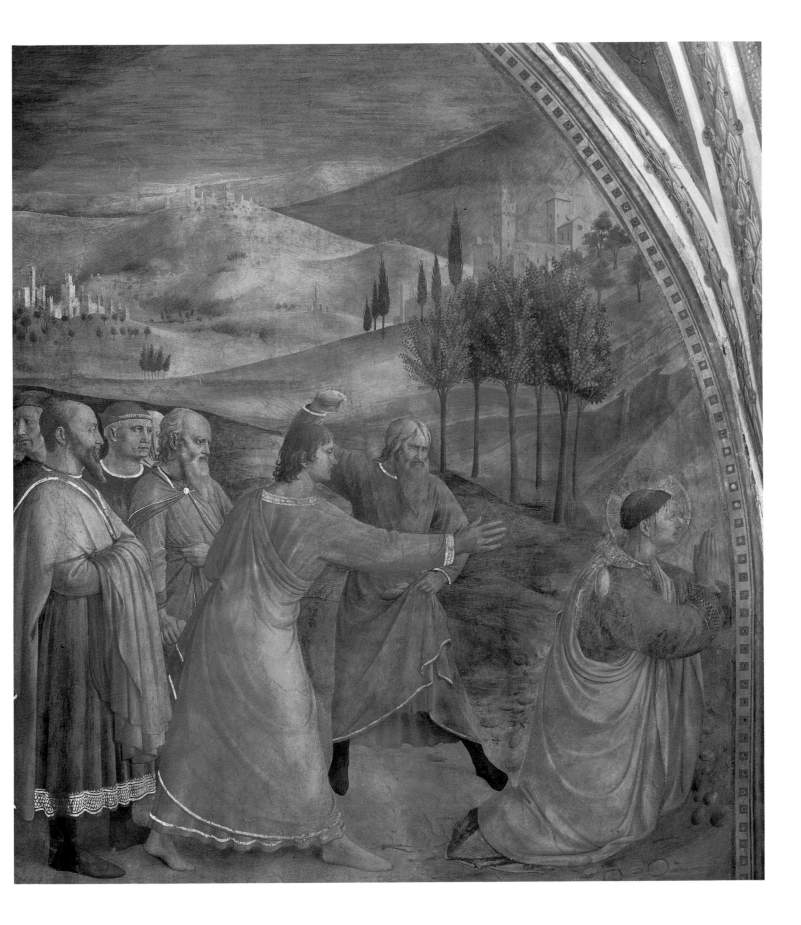

The Ordination of St Lawrence

c.1447-8. Fresco, 271 x 197 cm. Chapel of Pope Nicholas V, Vatican

In its setting in the Chapel of Pope Nicholas V in the Vatican, the dramatic impact of this fresco is aided by its position between two recessed windows. The scene is set in the nave of a basilica, the type of architectural space which in *St Lawrence distributing Alms* (Fig. 10) was used only as a backdrop. Five columns are visible on either side, and they are equalled in volume and monumentality by the bishops and other churchmen who witness St Lawrence kneeling before the Pope. The end wall of the basilica and its niche bring emphasis to no figure in the composition, for none stands at the centre. The central axis runs instead through the communion chalice which passes between the Pope and the saint. Comparison between this painting and the admittedly much smaller predella panel from the Cortona *Annunciation* of 1432-3, *The Presentation of Christ in the Temple* (Plate 9), shows how both Angelico's figures and his architectural settings have grown in clarity and plasticity. The Vatican chapel fresco which depicts the ordination of St Stephen by St Peter, of which a detail is shown here (Fig. 30), also emphasizes the communion chalice. The whole series of frescoes stresses the giving and receiving of alms and of communion.

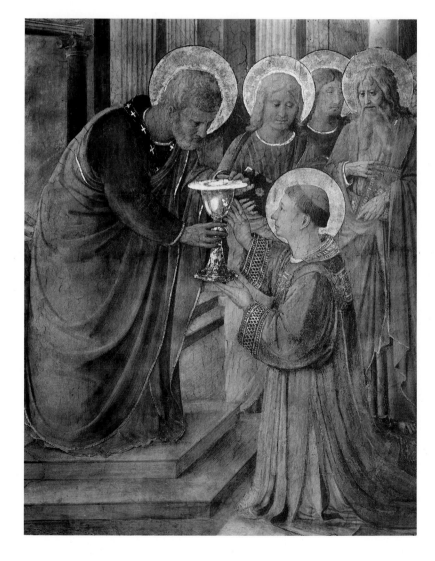

Fig. 30
St Stephen and
St Peter, detail of
The Ordination of
St Stephen

c.1447-8. Chapel of Pope
Nicholas V, Vatican

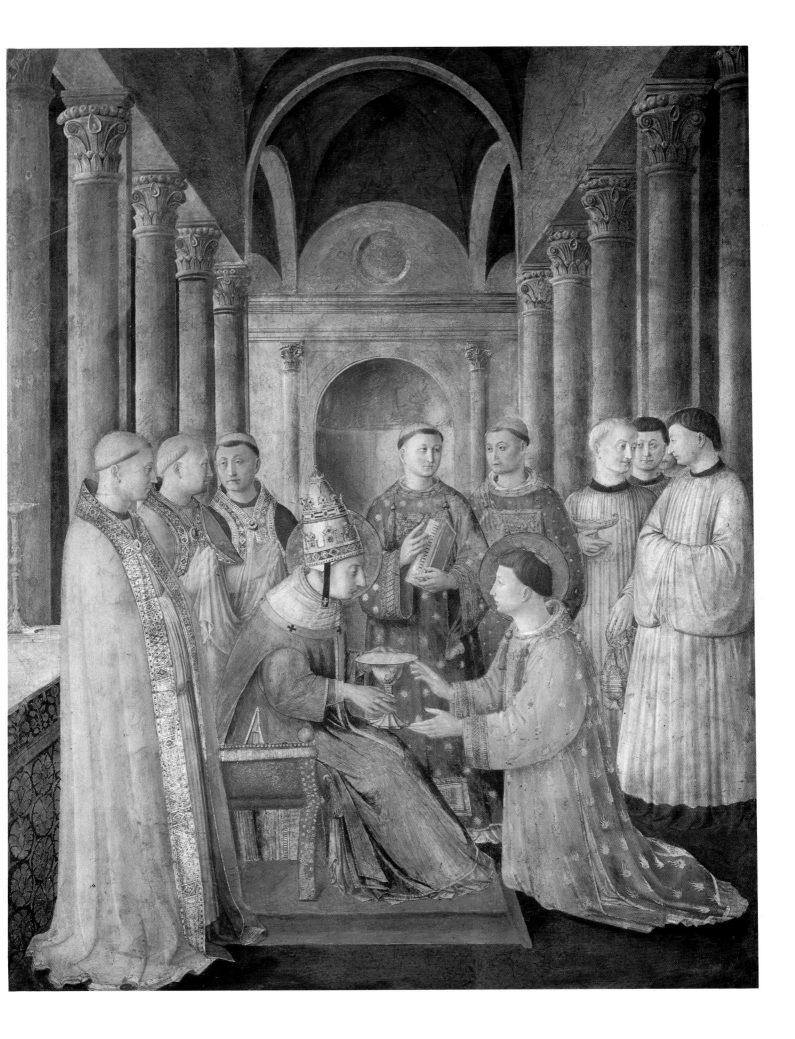

38

The Bosco ai Frati Altarpiece:
The Virgin and Child Enthroned with Two Angels between Sts Anthony of Padua, Louis of Toulouse, and Francis, and Sts Cosmas and Damian and Peter Martyr

c.1450. Panel, 174 x 174 cm. Museo di San Marco, Florence

This altarpiece, painted by Angelico in about 1450 after his return from Rome, shows further developments of the formula that underlies his earlier *sacra conversazione*. The architecture is richer and more plastic, so that its articulation of the picture space is partly camouflaged. The throne has been widened and heightened, now looking like the apse of a small church, bringing greater emphasis to the Virgin and Child at the expense of the saints. The wall is enlivened by a series of recessions and projections in the form of niches and half ionic columns. Although the grass and flowers have been excluded from the foreground, the natural world reasserts itself, albeit in a symmetrical composition, behind the wall.

39 The Coronation of the Virgin

c.1450. Panel, 213 x 211 cm. Louvre, Paris

A date of 1450 is now considered compatible with the internal dating evidence of this altarpiece. Unless the low view-point of the chequered floor was an innovation in this work, it cannot have been painted until after the first appearance of this technique in Florence in the 1440s, in Domenico Veneziano's *St Lucy* altarpiece. That the hexagonal canopy above the throne is overtly Gothic does not imply an early date, as its closest stylistic parallels are in the canopies over the figures of the Fathers of the Church in Angelico's Vatican Chapel frescoes of 1447-8. In this altarpiece he departs markedly from his usual methods of space projection, but this can be explained by the extreme difficulty of integrating so complex a composition as a traditional Coronation, into the type of space he had recently employed. The whole, although still a heavenly scene, is set on *terra firma*. The sky is a realistic blue and not gold. The very low view-point enables the assembled saints and angels to be placed in a series of tiers without obscuring one another. The figures in the foreground kneel so as not to attract undue emphasis. Mary Magdalen holds out her jar of oil, marking the central axis. Comparison with Angelico's earlier *Coronation* (Plate 19) shows how he has insisted on siting this second one in real space, just as he did with his first *sacra conversazione* in the San Marco altarpiece.

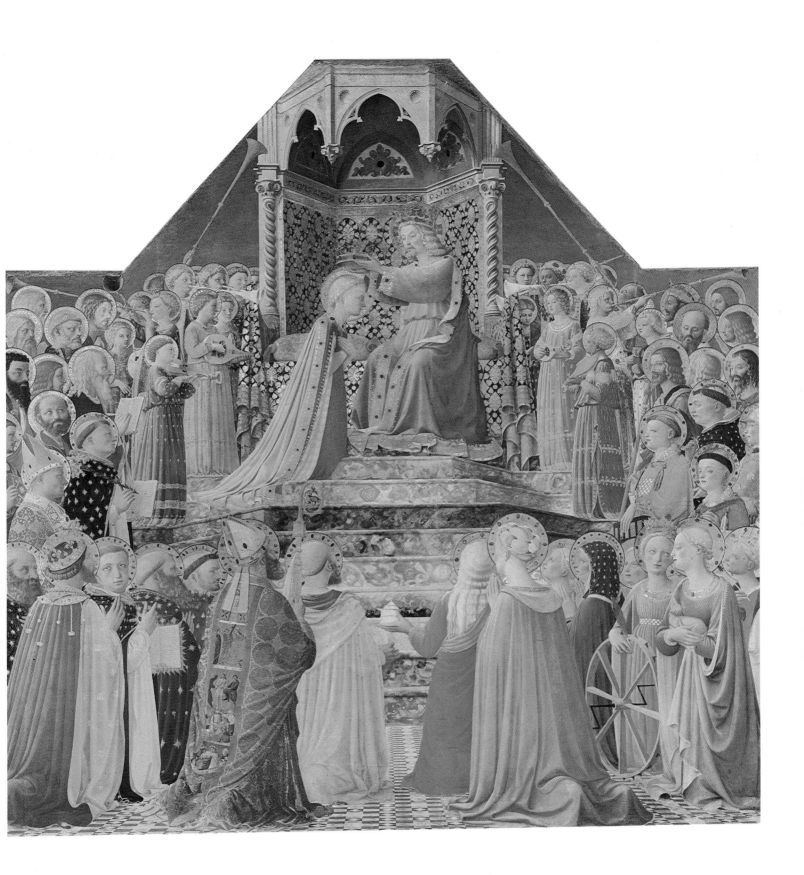

Detail from 'The Coronation of the Virgin'
(Plate 39)

St Nicholas of Bari is shown kneeling in the foreground of *The Coronation of the Virgin* with his episcopal mitre and crook. He is balanced by the blue robed figure of St Cecilia. Angelico had used a kneeling figure with his back turned to the viewer before, in that of St Damian in the San Marco altarpiece. It is likely that his inspiration for this came from Masaccio, one of whose frescoes in the Brancacci Chapel in Florence, *St Peter Adored by the Faithful*, shows just such figures with their legs hinted at by the fall of their robes. St Nicholas's cope shows several scenes from the Passion, including the Betrayal, Mocking, and Flagellation. To his left are St Anthony and St Francis of Assisi.

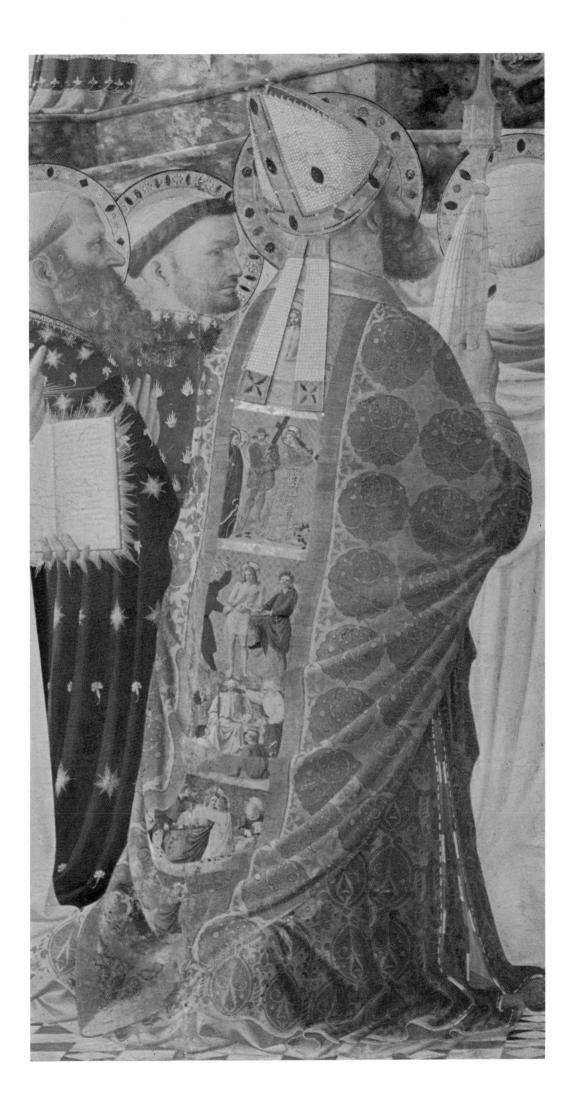

41 Detail from 'The Coronation of the Virgin'
(Plate 39)

St Catharine of Alexandria stands holding her wheel and regarding St
Agnes, who clutches her own symbol, a lamb. St Agnes's robe falls in heavy
sculptured loops to the ground. The haloes of the two saints are carefully
arranged so that St Catherine's face is not obscured. The haloes in this
painting are treated very flatly but in some cases also extremely decora-
tively, being studded with gems. They are markedly different from those
in the series of paintings by Angelico for the door of the cupboard at San
Marco, which are shown as shimmering discs of plain gold occupying a
genuine place in space.

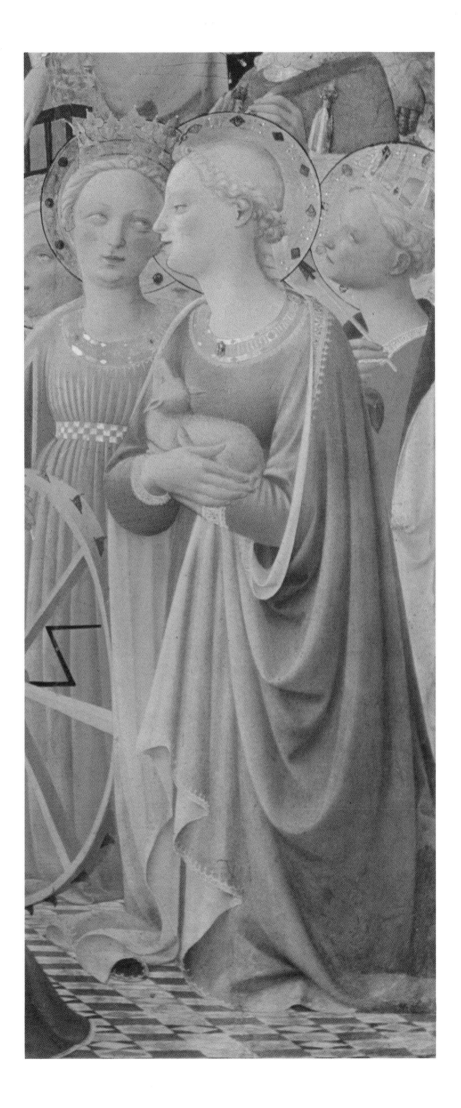

The Vision of Ezekiel

c.1451. Panel, 39 x 39 cm. Museo di San Marco, Florence

This and the following three panels (Plates 43-45) are part of a series, now consisting of thirty-five panels, commissioned by Piero de Medici for the doors of a cupboard at the San Marco convent, and depicting scenes from the life of Christ. In this, the first panel, the prophet Ezekiel and St Gregory the Great sit in a mountainous landscape with the river Chobar running between them. In the top left of the panel is a text from the first book of Ezekiel outlining the prophet's vision, which is shown below. Ezekiel leans back, his hands raised in surprise. His vision included four animalia who, 'had one likeness: and their appearance and their work was as it were a wheel in the middle of a wheel', (Ezekiel 1, v. 16). It is this wheel within a wheel which is shown here with a flaming circumference. Angelico depicts the wheel as being made of two concentric circles. Around the larger wheel is the account of the creation from Genesis, and around the smaller the first three verses of the Gospel of St. John, 'In the beginning was the Word, and the Word was with God, and the word was God ...', which echo the words from Genesis. At the top right of the picture is an excerpt from the writings of St Gregory, who interpreted the prophet's vision and used it to emphasize parallels between the Old and New Testaments. The theme of parallels between the two Testaments is pursued through all the other panels in the series.

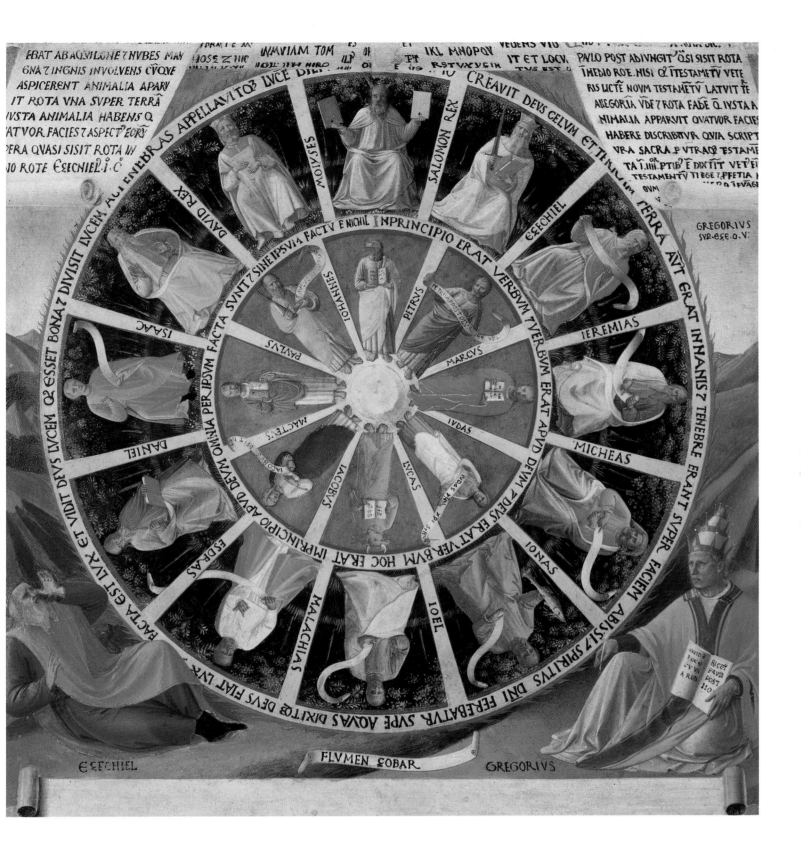

c.1451. Panel, 39 x 39 cm. Museo di San Marco, Florence

Herod, with crown and sceptre, watches from above the infanticide he has ordained. The sinister, dark-clad soldiers pour through the archway wielding black daggers against the children. The mothers, shown in a great variety of terrified postures and with looks of horror, attempt to protect their infants, but to no avail. Berenson said of Angelico that his optimism and belief in God was felt with such intensity that it 'prevented him from perceiving evil anywhere. When he was obliged to portray it, his imagination failed him'. This scene appears to belie those remarks, and those of others who interpret Angelico as an unworldly friar. The parallels between the composition of this scene and those of *The Attempted Martyrdom of Sts Cosmas and Damian by Fire* (Fig. 31) and *The Martyrdom of St Lawrence* have already been mentioned. A receding trellis is used here in the projection of space, and the device of the pots of plants on top of the wall seen in sharp perspective from underneath is also found in *St Lawrence before Valerianus* (Plate 35).

Fig. 31
The Attempted Martyrdom of Sts Cosmas and Damian by Fire

c.1440. A predella panel of the San Marco altarpiece. National Gallery of Ireland, Dublin

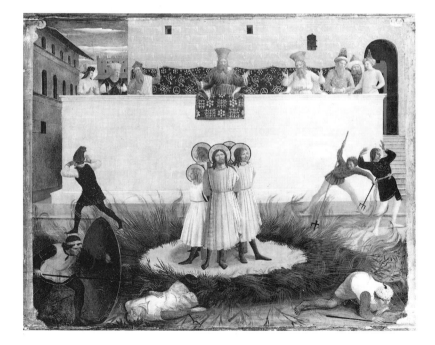

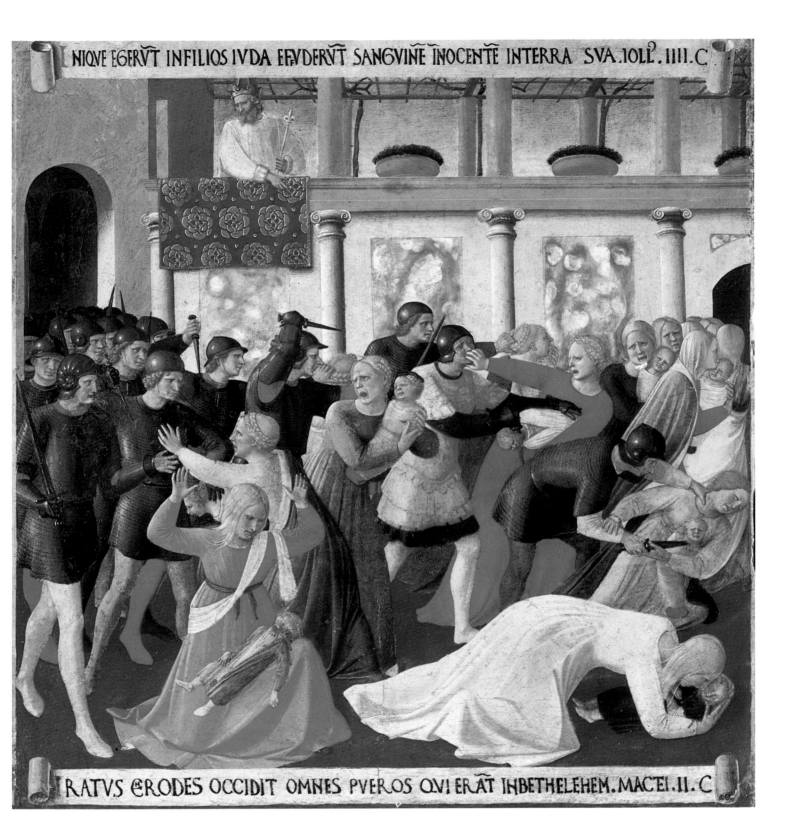

NIQVE EGERVT INFILIOS IVDA EFVDERVT SANGVIÑE IÑOCENTE INTERRA SVA. IOLL. IIII. C

RATVS ᴁRODES OCCIDIT OMNES PVEROS QVI ERᴀ̃T INBETHELEHEM. MACEI. II. C

The Circumcision

c.1451. Panel, 39 x 39 cm. Museo di San Marco, Florence

In the Temple, Christ is presented for circumcision. The table takes centre stage and its receding top leads the eye back to the choir. The forms of the three figures in the foreground are echoed in the background by the three arched walls of the choir and their windows. The chiefly vertical fall of the draperies of all the figures is painted with great discrimination, and echoes the fluting of the pilasters. Whereas in most of his frescoes in Rome Angelico used forms of architectural detail, such as mouldings and capitals, which appear never to have been actually employed in any real building, here he paints fluted and partly cabled composite pilasters. These architectural forms saw three-dimensional life in such buildings as Brunelleschi's Pazzi Chapel at Santa Croce in Florence, of 1430 or later. They appear again in another panel from this series, *The Presentation in the Temple* (Fig. 32), where a chiefly symmetrical architectural framework is once more used to frame and give emphasis to members of the Holy Family.

Fig. 32
The Presentaion in
the Temple

c.1451. Museo di San
Marco, Florence

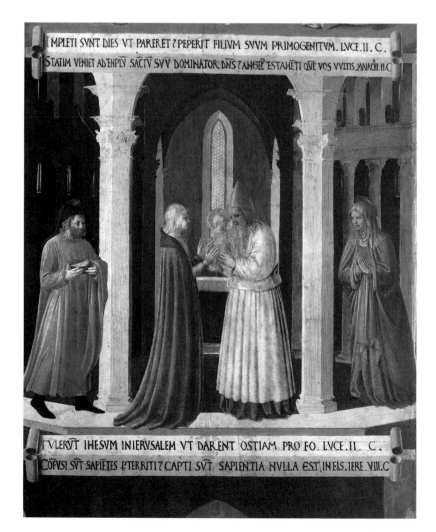

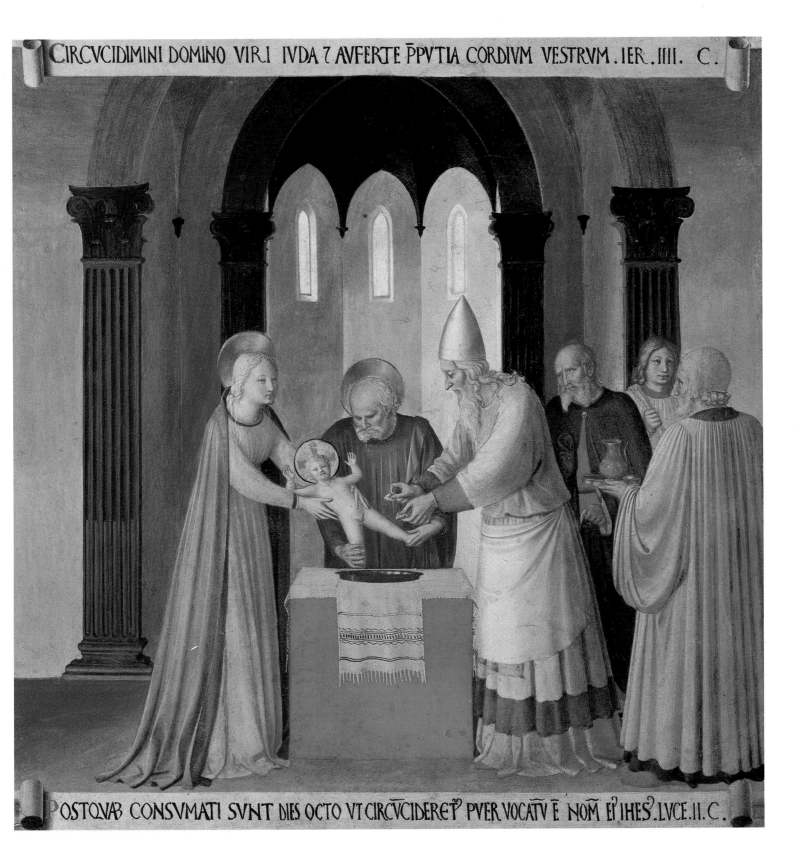

CIRCVCIDIMINI DOMINO VIR.I IVDA 7 AVFERTE ꝒPVTIA CORDIVM VESTRVM .IER .IIII. C.

POSTQVAꝰ CONSVMATI SVNT DIES OCTO VT CIRCVCIDERE͛ PVER VOCATV Ē NOM̃ EI̓ IHES̓.LVCE.II.C.

45 The Flight into Egypt

c.1451. Panel, 39 x 39 cm. Museo di San Marco, Florence

This scene shows the continuing influence on Angelico of naturalism. Having been warned in a dream, Joseph, Mary and the infant Christ make their escape from Herod's massacres by going into Egypt. Behind them a series of trees of diminishing size plots out the perspective of the landscape. The Holy Family is lit by a strong light from the left, the Virgin's draperies carefully delineated so as to show the position of both her legs as she rides side-saddle on the donkey. As in *The Circumcision* her halo is depicted as a three-dimensional object, which can both turn in space and reflect light. It was only late in his career as a painter that Angelico began to develop the spatial properties of the nimbus, which had first been experimented with by Massacio, for example, in the mid 1420s. In a further panel from this series, *The Annunciation* (Fig. 33), the Virgin's halo is treated with even more supposed realism, shown side-on as a plate hovering above her head. In the same picture the Holy Ghost is shown not hovering immediately above the Virgin in its own nimbus, but in naturalistic fashion as a bird high up in the sky.

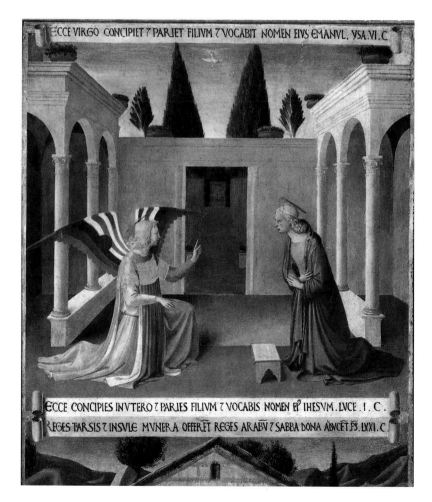

Fig. 33
The Annunciation

c.1451. Museo di San
Marco, Florence

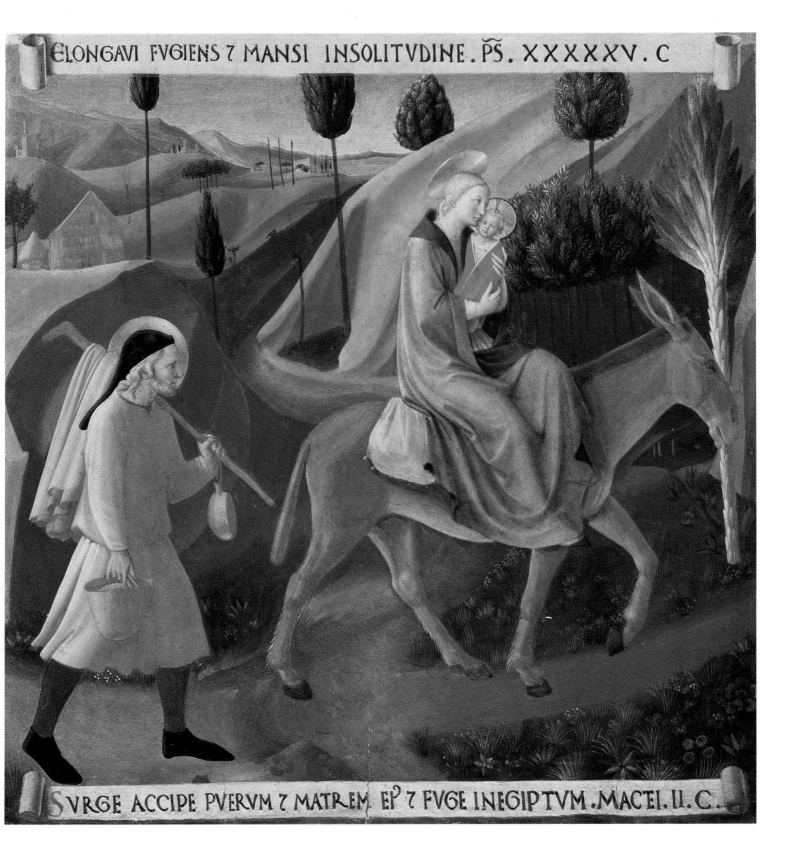

ELONGAVI FVGIENS 7 MANSI INSOLITVDINE . P̃S . XXXXXV . C

SVRGE ACCIPE PVERVM 7 MATREM EPꝰ 7 FVGE INEGIPTVM . MACEI . II . C .

The Adoration of the Magi
(with Filippo Lippi)

c.1452-3. Panel, 137.4 cm (diameter). National Gallery of Art (Kress collection), Washington DC

The argument that this circular panel (tondo) is in part by the hand of Angelico was first put forward by Berenson in 1932. Until then it was assumed to be the unaided work of Fra Filippo Lippi. The most convincing evidence for the involvement of Angelico is in the buildings at the top right of the painting. To anyone familiar with Angelico's work these are an immediate reminder of the architecture of Jerusalem in his *Deposition* (Plate 12), and the buildings in other of his works such as *The Decapitation of St Cosmas and St Damian* (Plate 26). When the edifices on one side of the tondo are compared with those on the other it becomes clear that two hands have been at work in this painting. The figures, too, have been shared: those on the left are by Lippi, whereas those on the right appear to be by Angelico or one of his assistants. The stable in the middle of the picture is a rather awkward structure and may represent a compromise between the schemes of the two artists who worked on the painting. It seems reasonable to assume that Angelico, the elder of the two and the one with the more primitive style, began the work and was succeeded by Lippi.

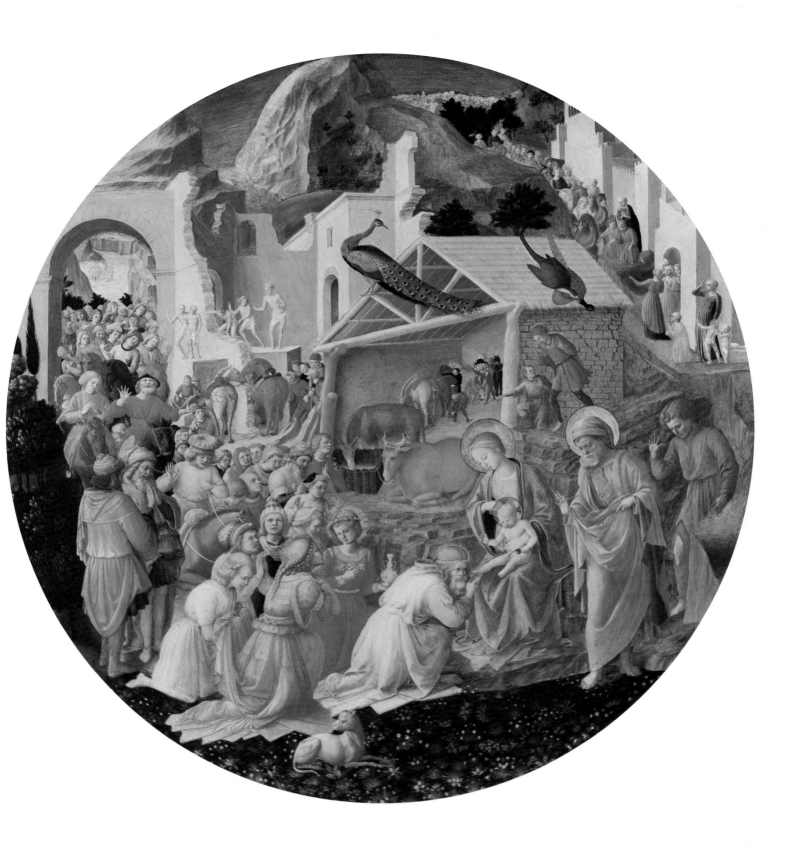

47 Detail from 'The Adoration of the Magi'
 (Plate 46)

This detail of the tondo by Angelico and Lippi shows the Virgin, the only one of the main figures in the work considered to be by Angelico. Comparison between her head and those of the Magus kneeling before her and Joseph to her left, reveals that they are modelled in completely different fashions. The braiding of her hair can also be compared with that of the two Marys in the panel from Angelico's series of pictures depicting the life of Christ for the cupboard at the San Marco convent entitled *The Maries at the Sepulchre*. The folds of Joseph's robes fall in the less realistic, more curvilinear style of Lippi. The manner in which the form of Mary's leg is so clearly shown under her robes is also reminiscent of the same feature of the Virgin in the *The Flight into Egypt* (Plate 45).

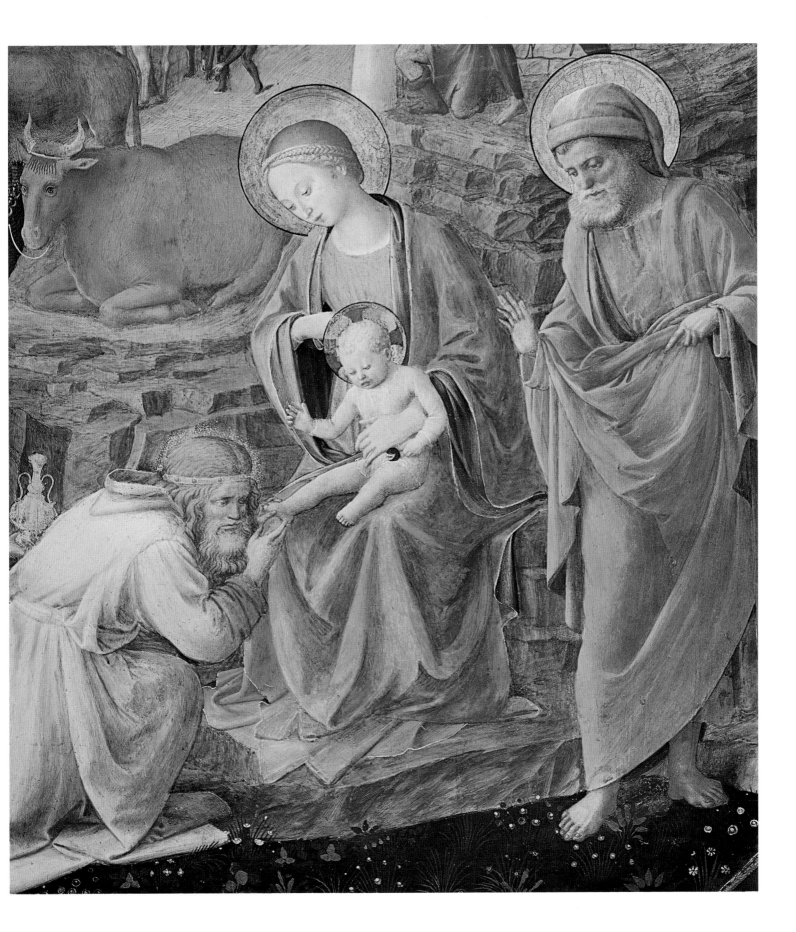

48 Christ on the Cross with the Virgin and St John the Evangelist Adored by a Dominican Cardinal

c.1450-5. Panel, 88 x 36 cm. Fogg Art Museum, Cambridge (Massachusetts)

This painting was originally the central panel of a triptych, and the figure of St Peter shown here (Fig. 34) formed a part of one of the wings. The arms of the cross stretch right across the panel, as if intended to strengthen its frame. The upper limb takes the form of a flourishing tree, a possible reference to the popular Legend of the True Cross which claimed that the wood used for the crucifixion came originally from the tree of Jesse. In the branches of the tree sits a pelican in its piety, plucking its breast so that blood flows to feed its young, a common symbol of Christ giving of himself for the redemption of the world. Cardinal Juan de Torquemada, a noted Dominican, kneels before the cross, his red cardinal's hat on the ground before him next to the rivulets of blood. On either side of the cross stand the Virgin and St John. The cross is in no landscape or other spatial setting. There is only an abstract gold ground behind. At the foot of the cross is a skull representing Golgotha. Its spartan design and intense, but quietly expressed, feeling make this a powerful image reminiscent of some of Angelico's earlier frescoes in the convent of San Marco.

Fig. 34
St Peter

c.1450-5. Panel
Private collection

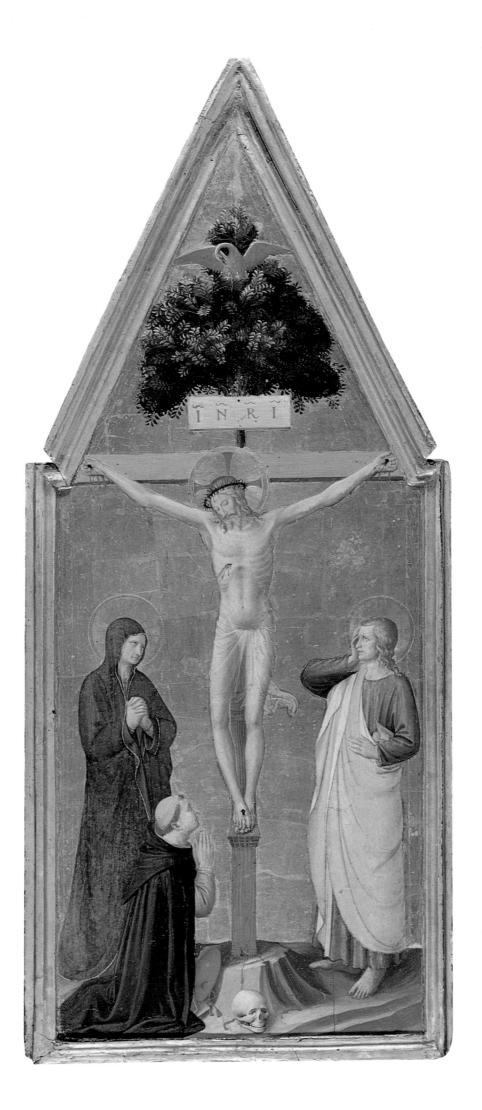

PHAIDON COLOUR LIBRARY
Titles in the series

FRA ANGELICO
Christopher Lloyd

BONNARD
Julian Bell

BRUEGEL
Keith Roberts

CANALETTO
Christopher Baker

CARAVAGGIO
Timothy Wilson-Smith

CEZANNE
Catherine Dean

CHAGALL
Gill Polonsky

CHARDIN
Gabriel Naughton

CONSTABLE
John Sunderland

CUBISM
Philip Cooper

DALÍ
Christopher Masters

DEGAS
Keith Roberts

DÜRER
Martin Bailey

DUTCH PAINTING
Christopher Brown

ERNST
Ian Turpin

GAINSBOROUGH
Nicola Kalinsky

GAUGUIN
Alan Bowness

GOYA
Enriqueta Harris

HOLBEIN
Helen Langdon

IMPRESSIONISM
Mark Powell-Jones

ITALIAN RENAISSANCE PAINTING
Sara Elliott

JAPANESE COLOUR PRINTS
J. Hillier

KLEE
Douglas Hall

KLIMT
Catherine Dean

MAGRITTE
Richard Calvocoressi

MANET
John Richardson

MATISSE
Nicholas Watkins

MODIGLIANI
Douglas Hall

MONET
John House

MUNCH
John Boulton Smith

PICASSO
Roland Penrose

PISSARRO
Christopher Lloyd

POP ART
Jamie James

THE PRE-RAPHAELITES
Andrea Rose

REMBRANDT
Michael Kitson

RENOIR
William Gaunt

ROSSETTI
David Rodgers

SCHIELE
Christopher Short

SISLEY
Richard Shone

SURREALIST PAINTING
Simon Wilson

TOULOUSE-LAUTREC
Edward Lucie-Smith

TURNER
William Gaunt

VAN GOGH
Wilhelm Uhde

VERMEER
Martin Bailey

WHISTLER
Frances Spalding